THE ATHENS OF
ALMA TADEMA

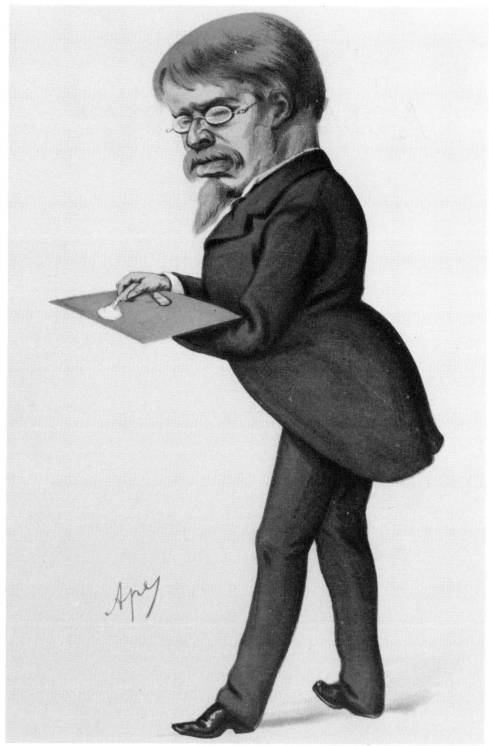

Fig. 1 *Ape* caricature of Sir Lawrence Alma Tadema.

THE ATHENS OF
ALMA TADEMA

Professor RICHARD TOMLINSON

ALAN SUTTON

First published in the United Kingdom in 1991 by
Alan Sutton Publishing Ltd · Phoenix Mill · Far Thrupp · Stroud
Gloucestershire

First published in the United States of America in 1991 by
Alan Sutton Publishing Inc · Wolfeboro Falls · NH 03896–0848

British Library Cataloguing in Publication Data
Tomlinson, Richard
 The Athens of Alma Tadema.
 1. Photography. Special subjects. Cities
 I. Title
 779.4385

ISBN 0 86299 876 X

Library of Congress Cataloging in Publication Data applied for

Jacket photograph: Pheidias and the Parthenon, 1868 by *Sir Lawrence Alma Tadema*
 (Courtesy of the Bridgeman Art Library).

Colour plates have been reproduced by kind permission of the Birmingham
City Art Gallery (2), Guildhall Art Gallery (3), Dick Institute, Kilmarnock (4),
The Sterling and Francine Clark Art Museum (6), Hamburger Kunsthalle (7),
Manchester City Art Gallery (8) (all courtesy of the Bridgeman Art Library) and
Walters Art Gallery, Baltimore (5).

Typeset in 11/13 pt Baskerville.
Typesetting and origination by
Alan Sutton Publishing Limited.
Printed in Great Britain by
The Bath Press.

CONTENTS

ACKNOWLEDGEMENTS

This book originated with an invitation from Dr Hector Catling, then Director of the British School of Archaeology at Athens, to give a lecture at the celebration of the School's Centenary in 1986. To illustrate this, I turned to the Alma Tadema Collection in the library of the University of Birmingham for photographs of Athens at the time the School was founded. The photograph which immediately drew my attention was Stillman's view of the Acropolis from Ardettos (Plate 1). The contrast between this idyllic scene and the concrete jungle of the modern city made a spectacular introduction to my lecture.

At that time I knew nothing of the photographers, but the existence of Stillman's signature on this, and other photographs in the Collection, stimulated my interest. I was given much useful help by Mrs P. Wilson Zarganis, Assistant Librarian at the British School, who drew my attention to one of Stillman's books in the Library of the School; and by Professor Peter Warren of Bristol, who enlightened me on Stillman's importance to the archaeology of Crete. Most fortunately, my reference to Stillman and the Alma Tadema Collection in my lecture was reported to Gary Edwards, who wrote to me. My debt to him, and his encyclopaedic knowledge of photography in Greece in the nineteenth century, is incalculable. He also put me in touch with Anne Ehrenkranz of The Center for Photography in New York, who was then preparing the exhibition of Stillman's work presented at the Center in 1988.

Professor Sir John Boardman told me about the Stillman prints in the collection of the Ashmolean Museum. He also pointed out to me that Stillman's negatives passed into the possession of the Society for the Promotion of Hellenic Studies in London, who sold prints from them in the nineteenth century. Miss Ana Healey, formerly the librarian of the Joint Library of the Hellenic and Roman societies in Gordon Square, conducted an excavation in the collections of the Library, and duly produced the surviving Stillman negatives, one from the original 1869 photographs, the remainder of the duplicate series which he took in 1882. From these beginnings, I was encouraged to pursue the other photographs of nineteenth-century Athens in the Alma Tadema Collection.

My colleague Jeffrey Orchard and his wife Jocelyn told me about the collection of Bonfils photographs at the Harvard Semitic Library, and gave me photocopies of articles about them. Dr Ian Jenkins of the department of Greek and Roman Antiquities in the British Museum gave me much useful information about the nineteenth-century photographs of the Elgin Marbles and the plaster casts, which

he is studying, and showed me the extensive collection of photographs in their archive. Mr T. Açik, student of the British School at Athens, drew my attention to Engin Çizgen's book on photography in the Ottoman Empire, which gave me much information about J.P. Sébah. I am most grateful to Ken and Diana Wardle for the loan of their copy of the *Ape* caricature of Sir Lawrence Alma Tadema (fig. 1); to the Managing Committee of the British School at Athens for permission to reproduce material in the library of the School; and to my photographer, Graham Norrie, for making the copies of the original prints which have been used in this book.

My greatest debt is to Dr Benedikt Benedikz, Special Collections librarian at Birmingham University, who encouraged me to delve into the Alma Tadema Collection, and enthusiastically produced the massive portfolios which contain the photographs. Without his help and support none of these studies would have been possible.

SIR LAWRENCE ALMA TADEMA

And His Photographic Collection

The Classical world of Greece and Rome was an important element in that strange compound of influences which made Victorian England. Classical literature, of course, formed the basis of the educational system, both in the schools and the universities. Even though the neo-Greek enthusiasm in art and architecture which had flourished at the beginning of the nineteenth century had in part yielded to a medieval reaction, particularly in architecture, the Classical world continued as a popular theme in painting. Sir Lawrence Alma Tadema, a Dutchman who settled in England in 1870, was one of the foremost producers of Classical painting. He chose not to base his work on the myths and legends of the Classical world (which, of course, had largely formed the subject matter of the original art of Greece and Rome) but instead to re-create a never-never world of everyday life, which transported his Victorian models to a dream land of blue skies and glistening marble, where they were clothed in the swirling, clinging draperies that everyone knew were typical of antiquity – or which, at times, revealed a nudity that the Victorians considered permissible in a Classical context not necessarily limited to the Roman baths. (The Bishop of Carlisle however did condemn Alma Tadema's explicity full frontal female nude 'A Sculptor's model' (Opus CLXXIX of 1877) ' . . . for a living artist to exhibit a life-size, life-like, *almost photographic* [author's italics] representation of a beautiful naked woman strikes my inartistic mind as somewhat, if not very, mischievous'.) Needless to say, unlike ancient Classical art, where the reverse was true, Sir Lawrence restricted such nudity to his female subjects. These pictures act out the roles of domestic life, of public meeting place and exotic ritual in a way which secured for them a ready market, and for their creator prosperity and fame, a knighthood (in 1899) and, at the end (in 1905) the Order of Merit. Even after his death, when artistic values were already profoundly changed, the popularity of his art was continued as the basis for the Classical epics of the cinema, for whose settings the influence of Alma Tadema were all-important.

Whatever the value of this as art (and, after the inevitable fall from favour into oblivion, his paintings are once more commanding a high price) Sir Lawrence took

great trouble to achieve archaeological accuracy in the settings for his fantasy world, and it was to assist him in this that he made his collection of photographs.

Laurens Alma Tadema was born on 8 January 1836 in the village of Dronrijp in Friesland, Holland, the son of a notary Pieter Jelles Tadema and his wife Hinke Brouwer. Alma was a family name on his mother's side, and he was named after his god-uncle (*Patenonkel*) Laurens Alma. Adrianus Alma was his godfather. His father died in 1840; his mother, following his father's wishes, hoped that Laurens would become a lawyer, but his own preferences led him to art. Under the strain he suffered a breakdown, and, not being expected to live, was then allowed to do as he pleased, so he studied art – and recovered. At sixteen he went to the Antwerp Academy, where, in accordance with the policies of the Director Gustave Wappens, he began to paint scenes from early Dutch Flemish history, in contradistinction to those with a Classical content. He remained at the Academy until 1857, when he moved to the Studio of Louis de Taye, and then, after three years, to that of Henrik Leys. By this time he had already learned to paint his historical scenes 'with archaeological accuracy'. He visited England for the first time in 1862. During this visit he went to the British Museum, where he was profoundly influenced by the Egyptian antiquities: this resulted in an 'Egyptian' phase, his picture (numbered by him Opus XVIII) 'Pastimes in Ancient Egypt' dating to 1863. This picture shows a pair of rather bizarrely costumed dancers performing in front of a select audience, and accompanied by a band of musicians playing distinctly Egyptian stringed instruments; all this within an architecturally monumental setting, in authentic Egyptian style. Though the scene appears now to be little more than a nineteenth-century fancy dress party, the dress and the setting is recognizably Egyptian. Clearly Alma Tadema was striving for authenticity. Though he later abandoned Egyptian subjects, his photographic collection contains several views of Egyptian monuments and sites, including photographs taken by Maxime du Camp in the late 1850s, and by Francis Bedford in 1862. His interest in Egypt was stimulated by his friendship with the Egyptologist George Ebers: between 1861 and 1864 he produced six paintings on Egyptian or Merovingian themes.

Between 1865 and 1867, however, the emphasis has changed: one Merovingian only, but thirteen on Classical themes. In 1863 he had married Marie Pauline Gressin, and for their honeymoon they went to Italy. He had planned to study the Early Christian churches: instead, he was overwhelmed with the Classical buildings and art, and this was to remain his main artistic theme for the remainder of his career. By now he was certainly collecting photographs, for two of those in his collection were actually taken on his honeymoon, showing him measuring and sketching in the House of Sallust at Pompeii (fig. 2). Roman subjects were to remain his principal theme, and it is photographs of Roman archaeology and architecture which dominate the collection. Greek subjects, though less frequent, begin to appear also at this time (the first was Opus XXX, 'A Soldier of

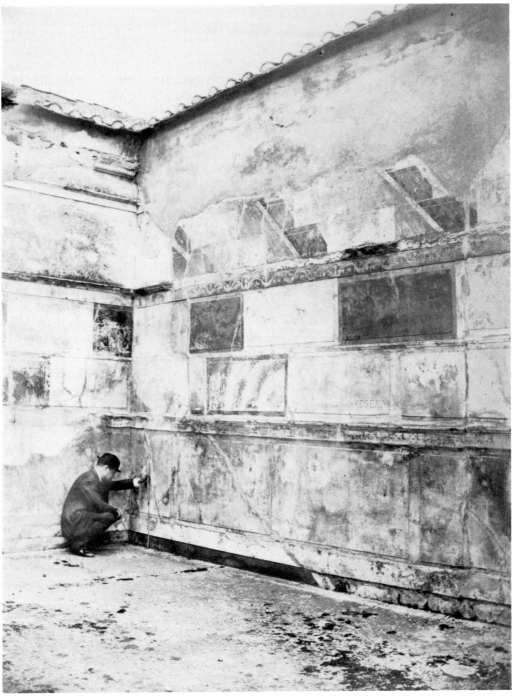

Fig. 2 Sir Lawrence Alma Tadema, measuring the panteo stucco wall decoration in the House of Sallust, Pompeii, on his honeymoon in 1863.

Marathon') but Alma Tadema had not yet any direct experience of Greece itself, as he had of Italy. His first major Greek picture, 'Pheidias and the Parthenon' (colour plate), is based rather on the parts of the frieze in the British Museum, of which there are photographs in the collection, and the major studies of the architecture and its painted decoration – then a subject of controversy – in published works such as F.C. Penrose: *Principles of Athenian Architecture.*

In 1869 his wife died of smallpox, a year after their infant son had also died. When the Franco-Prussian war broke out in July 1870 he decided to move from his home in Brussels and settle in London where he lived for the remainder of his life, being married for the second time, in 1871, to Laura Epps.

The photographic collection seems to have been built up particularly after he settled in London. A large number of the photographs, especially those of Greek subjects which appear in this book, date to the years around 1870; these include many of the photographs of the Elgin Marbles in the British Museum, as well as the sculptures of the Parthenon which remained in Athens. If these photographs *had* been acquired before 1874, they luckily escaped damage when the explosion of a barge on the nearby Regent's Canal wrecked Townshend House, where Alma Tadema then lived. Over the years the collection was enlarged, and one important aspect of it, particularly in the Greek sections, is the duplication of photographs over an interval of time, which provide an incidental, visual commentary on the progress of excavation, and conservation of the monuments.

Sir Lawrence Alma Tadema's collection of photographs was acquired, along with his library of books on Classical archaeology, by the Victoria and Albert Museum after his death in 1912. It was transferred, together with his books, to the library of the University of Birmingham in 1947, on the establishment of a separate department of Ancient History and Archaeology. It is contained in 161 portfolios each of which includes a variable number of photographs, together with original drawings and paintings of architectural and other details, some of them copied from various publications and some of them original, by Sir Lawrence himself.

Since the photographs were intended to provide examples for the details of his paintings, they were in general carefully chosen for that purpose. Portfolios 3 to 9, for instance, contain photographs of animals. Others contain examples of costume. Elements of Classical architecture are particularly important: there is a large number of photographs, for example, of different types of column and pilaster capitals, mostly from Roman buildings. There are photographs of altars, of arches, of fountains and houses at Pompeii, many of which reappear in his pictures. He was awake to the latest archaeological discoveries: the 'Prima Porta' statue of the Emperor Augustus, discovered at what is believed to have been the villa '*ad Gallinas*' of the Empress Livia in 1863, appears in his painting 'An Audience at Agrippa's' of 1876 (colour plate).

A catalogue of an earlier stage of the collection's formation survives at Birmingham University, together with the full final catalogue compiled by the

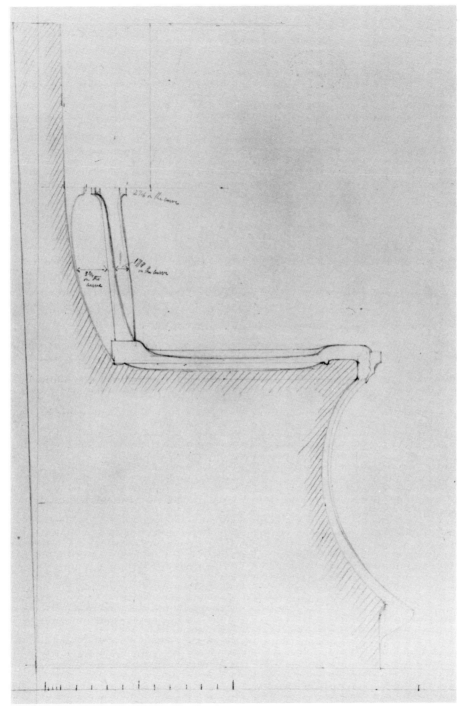

Fig. 3 Measured drawing of a stone chair or 'throne' in the Theatre of
Dionysus, Athens, included in the Alma Tadema Collection.

Victoria and Albert Museum (the catalogue numbers given in this book are those of the Victoria and Albert Museum inventory, although the year of acquisition by the Victoria and Albert, 1915, has not been included since it was the same in every case).

It is clear that Sir Lawrence was actively acquiring photographs by the 1860s, at a time when the development of the wet collodion process was completed and a number of professional photographers were at work in the various areas – and subjects – in which he was interested. Many of the photographs come from the commercial lists of companies like Marion and Co., who sold the photographs of Francis Bedford and others. Sir Lawrence himself was perhaps the most cosmopolitan of the artists working in London in the second half of the nineteenth century: not only was he Dutch by origin, but he had established his early career – and reputation – in Paris, and he was familiar also with the firms selling photographs in Paris, Italy and elsewhere. His notes on several of the photographs, and on his own drawings, are in French. This cosmopolitan character of the collection is one of its most noted features.

It also includes photographs which seem to have been commissioned by Sir Lawrence himself: among the earliest are those taken while he was on his honeymoon at Pompeii in 1863. There are probably others, not bearing the usual signatures or catalogue numbers of the commercial photographers, which may also have been taken especially for Sir Lawrence, though unless the people in them can be recognized it is difficult to prove this: there are three photographs (Plates 54–6) among those of Greece which do not appear to be commercial in form (or, indeed, quality) taken in the Theatre of Dionysus, a structure whose stone seats seem to have been of particular interest to Sir Lawrence. The collection also includes measured drawings of these seats (fig. 3), as well as detailed photographs, and they reappear in his painting 'Sappho' of 1881; but, as will be seen from the catalogue descriptions, these photographs remain anonymous.

The dates on which the commercial photographs were taken are not, of course, necessarily the dates at which Sir Lawrence purchased them, but active acquisition in the 1860s seems certain. Not only are there the photographs by Maxime du Camp, Frank Mason Good and Francis Bedford which date to that period, the time of Sir Lawrence's Egyptian paintings; it also includes photographs of the 1870s, by Felix Bonfils of Beirut and J. Pascal Sébah of Constantinople, who of course also features in the Greek section.

ATHENS IN THE 1870s

The photographs of Athens in Sir Lawrence's collection range in date from 1862 (Francis Bedford's photograph of the Propylaia) to 1882, the date of the second series taken by William J. Stillman. The bulk of them date to 1869 (Stillman's first series) or shortly afterwards (the photographs by Felix Bonfils and J. Pascal Sébah). Thus they were taken barely a generation after the independence of Greece had been established, and they show Athens, and above all the monuments, as they were in the first stage of their re-development and conservation by the Greek Authorities: they form an important visual record of this.

When Greece became independent Athens was a relatively small town, probably with under ten thousand inhabitants. The Turks had been driven out of the Acropolis in 1822, and a Greek garrison installed, but this finally succumbed to a violent siege in 1827, after which the Turks resumed occupation. In the Turkish period the town of Athens was situated largely to the north of the Acropolis, and divided into several communities: Turks in the houses at the immediate foot of the Acropolis itself, Greeks further out, Albanians (settled in Athens in the Middle Ages) to the west, and so on. Buildings and other remains of the Turkish period can be seen in the Alma Tadema photographs; not much more in the town than still survives at the present day, but much more of the fortifications round the Acropolis, which were not demolished until the late 1880s. The damage inflicted on the town during the War of Independence was considerable. Large numbers of the houses were thoroughly ruined, and the monuments of the Acropolis did not escape unharmed. Thus, when the city became free, there was considerable scope for development and renewal: it is this phase that is captured in the photographs.

To a certain extent the form of the renewal was imposed on Greece by the protecting powers which had guaranteed the treaty of independence. After some confusion (and hopes, among the Greeks, that they would be completely free to manage their affairs their own way), they had imposed on the new state a western form of monarchy and a king, Otho, who was a member of the Bavarian royal family. He brought with him German helpers, advisers and experts: the decision was taken to develop Athens as the capital of the new state, and to give it a form worthy of its new status. A new street plan was laid out to the north of the existing built-up area.

In contrast to the old town, the new plan was to be regular (and therefore imposing), a triangle of streets radiating from a 'Place de la Concorde' (*Omonia*, in Greek). This was to have a new, straight, street at its base – Hermes Street – which was created by improving the alignment of certain existing roads, and driving

Fig. 4 Photograph taken by W.J. Stillman in 1869 of the Acropolis, seen from the tower of the
new Cathedral (Plate 2).

through new sections of road where necessary to link them. To go with this, and
reflecting the appropriately neo-Greek style which was much favoured in Munich,
new Classical buildings were planned and constructed to be worthy of the new
capital (many of which still survive). A large cathedral was begun to celebrate the
triumph of Orthodoxy, and the city entered the first phase of its existence as the
capital of a Greek state, however heavy the Bavarian influence on it was. Otho was
still king of Greece when Francis Bedford, at the express wish of Queen Victoria,
accompanied the Prince of Wales and his party on his improving tour to the Holy
Land, Egypt and Greece, but he did not survive much longer. However, his
downfall did not lead to a purely Greek state: he was replaced by a new western
monarch, Prince George of Denmark. In essence, there was no real change and the
Athens captured in the photographs in this collection is still that of Othonian
Greece.

 This period had been one of quite intense archaeological activity, and the results
of this can be seen in the subjects of most of Sir Lawrence's collection of Greek

photographs. The original intention, promoted by the planning of the new Athens, had been to convert the area of the ancient city, or much of it, into an archaeological park. This however would have involved the expropriation of too many proprietors of the Greek part of the existing town who, not surprisingly, preferred to rebuild their shattered houses. The town at the foot of the Acropolis soon resumed its previous form (which essentially it retains to the present day). None of Sir Lawrence's photographs shows the extensive areas which are now archaeological zones – the Agora, the Roman Agora, the Library of Hadrian; the excavation in each of these cases was carried out later than the 1870s.

The Acropolis was another matter. After the Turkish garrison and its last commander, Osman Effendi, finally left the Acropolis on 10 April 1833, the citadel was taken over by a contingent of Bavarian troops. During the last years of Turkish rule interest in the Greek monuments had been fostered by Greek scholars, particularly Kyriakos Pittakis, who had made a detailed study of whatever ancient inscriptions he could find. He immediately pressed for permission to excavate on the Acropolis – and particularly around the Parthenon – in search of fallen

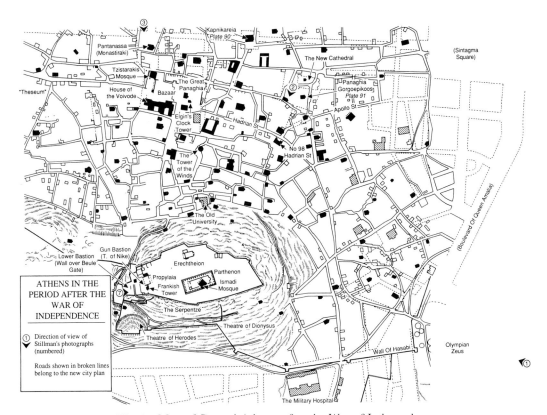

Fig. 5 Map of Central Athens, after the War of Independence.

material which most certainly existed (Lord Elgin had found sculpture by excavation, as well as removing visible pieces from the ancient buildings on the Acropolis). As soon as the Turks had left, with sparse funding provided by friends Pittakis began excavating, and in May 1833 began to find slabs from the Parthenon frieze, as well as inscriptions. The latter were taken to a depot which he established in the ruins of the church of the Great Panagia in the bazaar, next to the tower which, having housed the clock presented to the city by Lord Elgin in 1814, was now being used as a prison.

In July 1834 the architect Leo von Klenze arrived in Athens to advise Otho on the development of his capital. His advice concerning the Acropolis was crucial: it should be demilitarized and systematically cleared. At a ceremony in the Parthenon the beginning of its restoration was proclaimed. The work was not, however, given to Pittakis, despite his long record of concern for the monuments. Instead, a young German archaeologist, Ludwig Ross, was put in charge, assisted by two architects: Eduard Schaubert and Stamatos Kleanthis (who was soon replaced by another German, Christian Hansen). The ruins of the Turkish houses on the Acropolis itself were steadily dismantled, and the rubble tipped over the side of the Acropolis, mainly on the south and at the east end. These dumps survived until the 1870s, and are clearly visible in photographs taken before the mid-1870s.

More importantly, work began on dismantling a Turkish gun bastion outside the Propylaia, where Elgin had already found parts of the sculpture from a small Greek temple. In April 1835 this work revealed the base of the temple itself, as well as the greater part of its dismantled superstructure. This, of course, was the small Ionic temple of Nike (Victory), and its discovery marks an important turning point. Ross and his architects soon realized that they had enough original material surviving to attempt the reconstruction of the temple. The re-erection started in December 1835. Crucial elements that were missing (such as fragments of the shattered columns) were replaced in the same material, Pentelic marble. By May 1836 the immediate work was complete (two of the western columns were only partly re-erected at this stage) and the temple could now be appreciated as a building in its own right. It was immediately admired for its superb architectural qualities – and confirmed the policy that the Acropolis should be cleared, as far as possible, of later encumbrances, so as to reveal the full beauty of the Classical buildings.

Soon after this a row developed between Ross and Pittakis, over the publication of an important inscription found in the Piraeus. Ross resigned and Pittakis became, as he so rightly deserved, *Ephor* (Inspector) of the antiquities of the Acropolis, a post he held till his death in 1863. The earliest photograph in this collection, that by Bedford (Plate 10), is of part of the Acropolis while it was under Pittakis' direction, and though the others belong to the years after his death – when a new policy was being developed for safeguarding the discoveries made during the clearance work – this had not begun to take effect until after the early

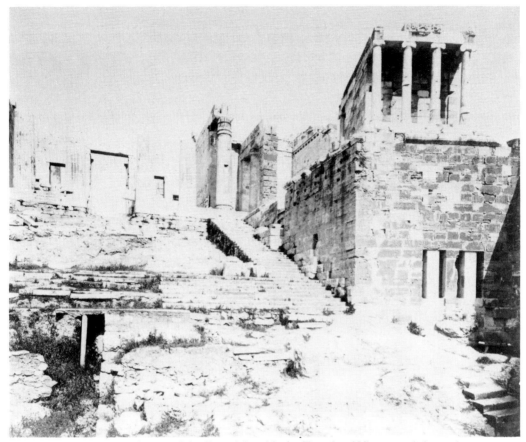

Fig. 6 The Western façade of the Propylaia with the Temple of Victory and the ancient steps
(W.J. Stillman, 1882, Plate 9).

Stillman, Bonfils and Sébah photographs. These show us essentially the Acropolis
and its monuments as they had been cared for by Pittakis (and in the case of one
photograph by Bonfils (Plate 93), how Pittakis stored the Byzantine fragments in
the Great Panagia).

Pittakis' work was directed to cleaning and to conservation of the monuments.
Although the Acropolis looks open and accessible in the photographs, access to it
was in fact carefully controlled: the days when hordes of midshipmen from the
visiting fleets of the western powers could unrestrictedly break off pieces of
sculpture as souvenirs were, if not completely ended, severely restricted (in fact,
there is only one known instance, when an Austrian midshipman got away with a
foot from a Parthenon metope, now lost and known only from a cast in the British
Museum). Visitors – including the photographers whose work is shown in this
volume – would have needed permission to enter and work in the Acropolis.

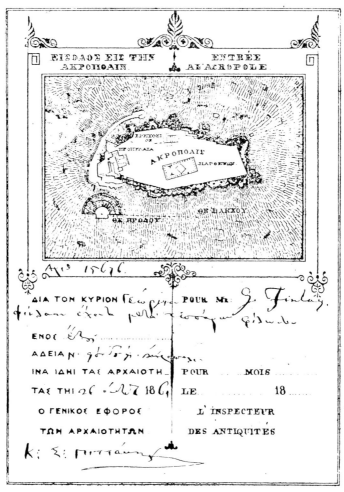

Fig. 7 Acropolis Pass issued to George Finley, the historian, by Pittakis in 1861. Note that the plan on the pass still shows the Acropolis as it was immediately after the War of Independence.

Another person who had to be given written permission by Pittakis to go with four friends on to the Acropolis was the distinguished British Philhellene, George Finlay. He was·one of those who had come to Greece with Lord Byron to fight for her independence, and who had survived to take up permanent residence in Athens (where his house still just about survives) and to become the most important nineteenth-century historian of Greece. His pass survives along with his books and other papers in the library of the British School at Athens.

The task of protection grew more onerous as more and more material was revealed by the clearing operations. Sculpture and architectural fragments had to be stored, and there were no museum buildings for them. They were kept in whatever structures still survived on the Acropolis (a Turkish cistern to the west of

the Parthenon, various Turkish buildings east of the Erechtheion) but otherwise, as far as possible, in the ancient buildings to which they belonged. Pittakis' slabs from the frieze of the Parthenon were kept inside the temple, stood up against the north wall; the relief slabs from the parapet that had surrounded the Temple of Nike stood inside the temple. Bedford's photograph of the Propylaia shows an array of architectural fragments, and some wooden shelving on which pieces were kept, and Stillman's photographs (especially Plate 9) show the same arrangements in 1869. Indeed, Ludwig von Sybel's catalogue of the Sculptures in Athens, published in 1881, still lists pieces that were kept in the *Hof der Invaliden*, the Turkish forecourt below the entrance to the Acropolis, whose walls and gates still survived. By this time, however, the main museums, on the Acropolis and the National Museum on Patision Street, had been built, and their first collections moved into them. (So the later Stillman photographs of the Acropolis show the Parthenon no longer containing the slabs from the frieze put there by Pittakis.)

Cleaning and conservation proceeded steadily. The main clearance of Turkish rubble took place in the 1830s: by the time the very first surviving photographs of the Acropolis were taken (the daguerreotypes of Girault de Prangey in 1840–44) most of the small Turkish buildings, which hem in the ancient monuments in the drawings and paintings of the early nineteenth century, had gone. The little mosque of the Ismadi, built in the ruins of the Parthenon after its destruction, survived long enough (until 1842) to be recorded in 1839 in a now lost daguerreotype by J. de Lotbinière, on which an aquatint of 1842 by Frederic Martens was based. But that went shortly afterwards (though it remained on the plan of the Acropolis, along with the Turkish gun bastion in which Nike was found, which decorates the pass issued to George Finlay as late as 1861). By the 1840s all ruinous and unimportant Turkish walling and buildings had been removed. All that remained were some pieces in or on the ancient buildings which either did not detract from their appearance, or were necessary to keep them up; and stretches of the battlements on top of the Acropolis walls. Of non-Classical buildings, apart from those used to house antiquities, all that survived were the great 'Frankish' tower, built on to the south-west wing of the Propylaia, and parts of the Byzantine conversion of the Parthenon into the Cathedral of the Holy Wisdom (*Ayia Sophia*); and these were still there to be photographed by Stillman in 1869 (though the apse of the cathedral was supposedly removed by C. Botticher in 1862).

At the same time repairs and restorations had to be carried out. The restoration of Nike has already been mentioned. Under Pittakis' administration, with the support of the Archaeological Society and various archaeologists and architects, Greek (Rizos-Rangabé, for instance) and foreign, the surviving remains were shored up and repaired. In the Parthenon the north wall of the *cella*, which was in a perilous state, was reinforced by mortared brickwork on its inside. This appears in the general interior views of the temple (such as Plate 21) and forms a backcloth,

where its rough and ready nature is all too apparent, to J. Pascal Sébah's photographs of the relief slabs (Plates 70–74). Otherwise not much was done. The lintel of the west door remained in a dangerous state, visible in Stillman's photographs: it was not repaired until 1872. The east pediment, or rather the southern fraction of it, was shored up by a piece of timber.

In the Erechtheion, early nineteenth-century pictures show the north facade of the north porch intact with all four columns standing (though the intervening spaces are all walled up), the entablature complete and even part of the pediment still in place. After the siege, in the War of Independence, this was in a ruined state: only the two eastern columns, and the section of entablature over them, were still in place, while two of the great marble ceiling beams lurched down drunkenly over the remains of the Turkish walling. This was tidied up. The ceiling beams were taken down and placed in front of the porch, the fallen columns partly repaired; and it is in this state that it appears in the photographs (e.g., Plate 40). The caryatid porch was also repaired, the caryatid taken by Elgin being replaced by a cast, the remains of the broken caryatid patched up, and missing pieces of the walling and entablature replaced in marble, though the work was done in a crude manner, so that there can be no confusion between ancient and modern work. This was done in 1846–7 by A. Paccard, and is visible in the photographs (Plate 43).

The Propylaia was cleared of encumbering Turkish walls, although Turkish walling still survived on parts of the superstructure. Repairs here were limited to reinforcing damaged column drums by means of iron bands, visible here (and on other buildings) in the photographs (e.g., Plate 7). Columns which were out of true were straightened, as far as possible, and it is recorded that, to save expense, some of the work removing later masonry that was causing a column to lean was done by Pittakis himself with his own hands.

Outside the Acropolis, besides the dismantling of the Turkish gun bastion, more Turkish walls and rubble were removed by E. Beulé in 1852–3, to reveal the Roman gateway constructed in the third century AD from demolished Classical buildings. The Beulé gate still bears the name of its discoverer, though in Stillman's album it is more austerely described as 'Ancient gate to the Acropolis'. (There is a calotype by A. Normand, in the collection of the École Français d'Athènes, which shows the west end of the the Acropolis before the discovery and excavation of the Beulé gate.)

The most recent work recorded in the earliest photographs of Sir Lawrence's collection dates to the 1860s: the excavation of the Kerameikos Cemetery, on the western edge of the ancient city, and of the Theatre of Dionysus (Bacchus) on the south slopes of the Acropolis. This was done, by the Archaeological Society, in the early 1860s. The Kerameikos excavations revealed splendid carved gravestones, which were stood up again in the area of the excavations, protected by wooden boxes built over them. Photographs by Sébah show them in that state (Plates 85 and 86). There are several photographs of the theatre, which obviously excited Sir

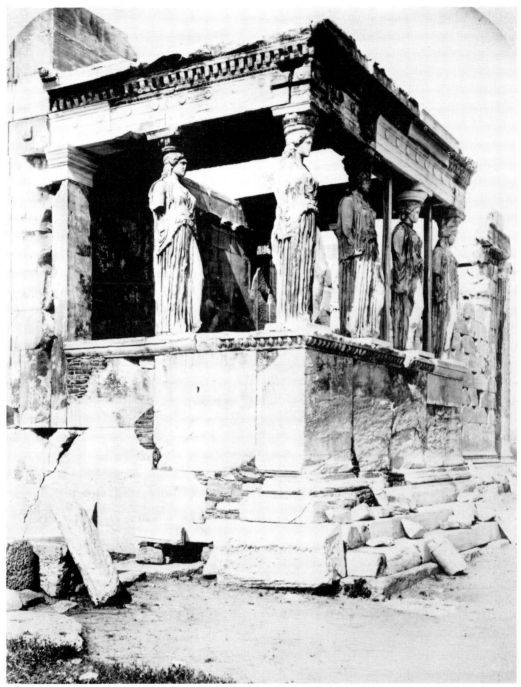

Fig. 8 Erechtheion, Porch of the Maideus (Caryatids) (W.J. Stillman, 1869, Plate 43).

Fig. 9 First century BC sculpture from the Theatre of Dionysus. Line drawing from the
excavation report of 1862 (Plate 83).

Lawrence, by all three photographers, Stillman, Bonfils and Sébah. Particularly
interesting is the general view by Sébah (Plate 59), which shows completely open
country and fields the other side of the new road which runs past the theatre.
Significant also is Sébah's photograph (Plate 83) of one of the sculptures found in
the excavation of the theatre, a relief of a dancer, now known to date to the first
century BC and possibly from some reconstruction of the stage building of that
date. This was photographed as it was then kept, propped up against a rough wall
in the theatre itself; but the photograph gives a direct and immediate impression of
the original (in quality it is every bit as good as more recent photographs of the

repaired slab as it is now in the National Museum); and contrasts with the line drawing of it published with the excavation report of 1862. Good though the drawing is, it underlines the importance of photography, not only to artists like Sir Lawrence, but to the archaeological study of ancient Greece.

The later photographs also catch the beginnings of new developments in Athenian archaeology. It is particularly easy to do this in Stillman's photographs, where his second series of 1882 deliberately repeats the earlier series of 1869, with the result that direct comparison is possible. Here we can see the 1872 insertion of a stone brick and cement arch over the west door of the Parthenon (Plate 27), an ugly intrusion but one which served to consolidate the fragmentary lintel until the more thoroughgoing restoration of Balanos at the beginning of the twentieth century swept it all away, along with the late Roman repair to the sides of the door, clearly detailed in Stillman's photograph and now gone for ever. This marks the demise of the Frankish tower, demolished, in the face of some protest, in 1875 at the expense of Heinrich Schliemann, in pursuance of the policy of revealing only the Classical monuments. What is left is, perhaps, less picturesque but it does have the inestimable benefit of making clear the design of Mnesikles' Propylaia, which is a unique architectural masterpiece (something the tower most definitely was not). The unsightly tips of rubble which disfigured the sides of the Acropolis have at last been removed (and deposited in the still open fields the other side of the road from the theatre of Herodes Atticus), making possible further excavation on the southern slopes of the Acropolis itself, which was conducted by the Archaeological Society in the 1870s and revealed, for instance, the sanctuary of Asklepios by the Theatre of Dionysus, duly photographed probably by Stillman (Plate 61).

THE PHOTOGRAPHERS

Some of Sir Lawrence's photographs were made especially for him – a clear example being the photographs which include him working in the House of Sallust at Pompeii in 1863 – but the majority would seem to have been bought commercially, either directly from the photographers themselves or through the various companies which sold photographs, in this country and abroad. The photographs by Francis Bedford were sold by Marion and Co. in London, ready mounted on card, with captions and Marion's own name, as well as that of the photographer. Sir Lawrence had several more of Bedford's 1862 series of photographs, in addition to the one of the Propylaia at Athens (Plate 10), mostly of views taken (on the same tour with the Prince of Wales, of course) in Egypt. It is not possible to say when these photographs were acquired, but they were presumably still available for some years after 1862. The same applies to other early photographs of Egypt in the collection, by Maxime du Camp. On the evidence of the photographs themselves, the main period of acquisition for the Greek part of the collection would seem to be the 1870s, though Alma Tadema was prepared to add to it the second series of photographs by William Stillman, taken in 1882 and sold in London by the Society for the Promotion of Hellenic Studies.

Not all the photographs can be attributed to a named photographer. No attempt was made by Sir Lawrence to add the photographer's name to the other details he recorded on the mounting card. Those which can be attributed are identifiable only by the existence of a signature on the photograph itself, put there either because the photographer believed he was producing a work of art which deserved to be signed in the same way as a painting (which is almost certainly true in the case of Stillman) or for reasons of commercial identification, presumably the reason in the case of Sébah and Bonfils. Others can be identified on external evidence – the later (unsigned) Stillmans because the Hellenic Society still possesses in its library the negatives, duly listed as the work of Stillman, and because of the survival of Stillman's own copies in Union College, Schenectady, New York – but there are others which cannot be identified at present (and for which an identification would be welcome).

How much interest Sir Lawrence took in the photographs, as photography, and in the people who produced them is problematic. They were for him potential tools and aids to be used in his own art, rather than works of art in their own right. His Stillman photographs are not the more expensive carbon prints, with accompanying text, that formed the sumptuous volume *The Acropolis of Athens, illustrated architecturally and picturesquely in Photographs by William Stillman*, but the cheaper

albumen prints sold separately in London. Quite clearly, however, Sir Lawrence knew of the existence of the album, for he copied on to the mounting cards of his own collection the captions printed in it (and occasionally got it wrong, where his numbered print did not coincide with the photographs included in the album). In fact, the collection includes almost all the photographs – or their equivalents – in the album. Since Stillman moved in artistic circles in London in the 1860s and 1870s, and began his career as a painter (albeit a follower and friend of the Pre-Raphaelites, Rossetti in particular, and of Ruskin, who was no supporter of the art of Sir Lawrence Alma Tadema) it is not unlikely that Sir Lawrence knew him. It is tempting to suggest that if Sir Lawrence himself did go to Athens to make the drawings of the thrones of the priests in the Theatre of Dionysus (of which there are measured drawings, annotated possibly by Sir Lawrence himself, in the collection at Birmingham University), he got Stillman to photograph the occasion (Plate 55). There were plenty of other photographers in Athens at this time, however, and certainty is out of the question. Francis Bedford, obviously, was a person of standing in London, and Sir Lawrence may have known him, though in both his case and that of Stillman the photographs were bought from their publishers. The other photographers worked overseas, Bonfils in Beirut, Sébah in Constantinople, where their photographs were sold to tourists (to whom those of Bonfils were recommended in Baedeker) but again, they also sold through agencies in other countries. It is impossible to guess how Sir Lawrence came by their prints.

These, then, are the four photographers whose Athenian photographs can be identified in the Alma Tadema Collection: Francis Bedford, William James Stillman, Felix Bonfils, J. Pascal Sébah (there is also one photograph, combined from two prints, by the Athenian photographers the Rhomaïdes Brothers, which was labelled by Sir Lawrence 'View near Athens', but is actually a view of the German excavations at Olympia in the second season, 1875–6). Francis Bedford contributes only one Athenian photograph to the collection. Bonfils is represented by twelve prints, Sébah by twenty, Stillman by forty-six, plus one which Sir Lawrence thought was by Stillman, but which may be by someone else. Besides these, in addition to photographs of Athenian sculpture no longer in Athens (principally photographs of the Elgin Marbles in the British Museum) there are six unattributable photographs taken in Athens itself.

The work of Francis Bedford is well known and described in the standard books on the history of photographs such as Helmut Gernsheim's *History of Photography* (1955). He was born in 1816, the son of an architect who worked in the Greek revival style, Francis Octavius Bedford. He himself followed his father's career as an architect but took up photography in 1853, like so many of its early practitioners in England, as a gentleman of means rather than as a professional. He was a member of the Photographic Society, becoming its vice-president in 1861. As a gentleman-artist he was socially acceptable, and thus was chosen by Queen Victoria to accompany her eldest son, Prince Edward (much as aristocrats

on the Grand Tour took artists with them) when he was sent, for the good of his soul and after an early scandal, to the Holy Land in 1862. The tour took the prince to Egypt and Syria, as well as the Holy Land, and to Greece, via Corfu (which was then still a possession of the British Crown). Bedford was allowed to sell the photographs he made, and these were published in 1862 as an album: *Photographic Pictures (made by Mr Francis Bedford during the TOUR IN THE EAST, in which by command he accompanied HIS ROYAL HIGHNESS THE PRINCE OF WALES (London, published by Day and Son Lithographers to the Queen, 6 Gate Street Lincolns Inn Fields)*. There were 172 views included in the album, 10″ x 12″, the same size as the print of the Propylaia in Sir Lawrence's collection (other Bedford prints in the collection are 8671 'Philae, The Lily of Pharaoh and small temple', 8673 'Philae Temple of Isis' and 8681 'Medinet Habu', dated Mar 18/61). The catalogue of Bedford's photographs, inviting subscriptions for the entire series, either of the sections or any special selections, is illustrated on page 107 of Engin Çizgen's book.

Felix Bonfils belongs to a slightly later generation. He was born on 6 March 1831 at St Hippolyte du Fort, near Alès in Provence. When the French sent an expedition to the Lebanon in 1860, as a result of one of the perennial clashes between the Druses and the Maronites, Bonfils accompanied it, having already developed an interest in photography. Presumably he saw the opportunities which that region offered with its wealth of historical monuments and the general and religious interest it aroused in the west. Urged by his wife, Lydie, who had visited Beirut in the following year, he finally settled there in 1867, and aided by her built up a sound reputation as a photographer of quality, his work strongly recommended by Baedeker. The studio was continued after his death in 1885 by his son, Adrien, until he sold up in 1894 – by which time, presumably, the market for professional photographs of the monuments and holy places of the Near East was dwindling in the face of the new technologies which put the art of photography within the range of the ordinary traveller. Many Bonfils prints had been acquired by institutions as well as individuals; by the Palestine Exploration Society; and by the Semitic Museum at Harvard University, where a large collection of early Near Eastern photographs, including eight hundred by the Bonfils family, were unexpectedly rediscovered as the result of a protest bomb set off in 1970. Despite the importance of Bonfils as 'a photographer of the Near East; of Lebanon, Palestine and Jerusalem', there is only one photograph by him of those regions in the Alma Tadema Collection, a photograph of the ruins of Baalbek. In general, Sir Lawrence's photographs of Jerusalem and the Near East are signed Saboungi. The Bonfils establishment had a branch at Alexandria, and there are several Egyptian photographs signed Bonfils in the collection. It seems likely that Sir Lawrence bought his Bonfils photographs in London, where they were probably sold by Mansell, the source of Sir Lawrence's photographs of the sculpture in the British Museum. (There is a letter from Mansell, dated 1892, to Professor David Gordon Myers, who built up the Harvard Semitic Museum, which says that he had heard

Fig. 10 Erechtheum wall crown (Bonfils, Plate 48).

from Bonfils (i.e., Adrien, not Felix) that he had made an addition of 150 views to his Egyptian series.)

Sir Lawrence's Bonfils photographs are much earlier in date than this, and are the work of Felix. In addition to the individual photographs, available separately by order from the Bonfils catalogues, Felix Bonfils published two albums of photographs, *Architecture Antique*, in 1872, and *Souvenirs d'Orient – album pittoresque des sites, villes et Ruines les plus remarquables de la Terre Sainte*, in 1877. The earlier album

contains eight photographs of Athens, the later ten. In the later volumes, views which already appeared in the earlier are repeated, but are made from new negatives, not those used in the earlier book. Slight differences between them – some photographical such as a slightly changed position for the camera, and some archaeological, such as the cleaning or moving of blocks from their earlier positions – make it easy to distinguish between the two series. It is thus possible to recognize Sir Lawrence's copies of Bonfils' photographs of Greece as belonging predominantly to the earlier series, and once these have been isolated it can be seen that they all have his signature on the print, where it appears in black, together with a reference number. This was already on the negative when it was used for the prints in the album, which again confirms the series. Nine of the Bonfils prints of Greece are of the early series, three are of the later. The archaeological evidence – particularly the position of the blocks of stone collected round the excavators' ramshackle hut in the Theatre of Dionysus – suggests that the early Bonfils photographs were taken a little later than those of William Stillman, which are securely dated 1869: they presumably belong to 1870 or 1871, just before the publication of the album.

Twenty of the Greek photographs in the Collection are by J. Pascal Sébah; there are others by him of Constantinople, where he had his studio. He was born in 1838 and established his photographic studio (which he called El Chark) in the Pera district of Constantinople in 1857, subsequently taking into partnership a Frenchman, A. Laroche. The first studio was on Postaçilar Street, but he later moved to No. 439 of the main street of Pera, the Grande Rue de Pera, very much the international quarter of Constantinople and where most of the professional photographers in the nineteenth-century city had their establishments. (Because Islam does not allow any representation of the human form, photographers were all of necessity, non-Muslims.) A signboard advertising Sébah and Joaillier survived on this building until the 1970s. In September 1873 the Paris magazine *Le Moniteur de la Photographie* published a letter from Laroche which sought to draw attention to the quality of work the Sébah studio was producing, on which the editor of the magazine commented favourably. In this letter Laroche describes Sébah as a Levantine; given his French Christian name, this demonstrates that he must have come from Syria or, more likely, the Lebanon (which in any case was part of Syria), so that he would have been of Turkish (or, more accurately, Ottoman) nationality, as Gary Edwards suggested in his note on foreign photographers in Greece, in the catalogue to the Benaki exhibition.

In 1873 Sébah opened a second studio in Cairo, where he collaborated with H. Bechard. An advertisement of 1880 gives the addresses of the Constantinople and Cairo studios, and offers complete collections of views in all forms of Egypt, Nubia, Greece, Constantinople, Bursa, Adrianople and Smyrna. In addition to photographs Sébah worked in photolithography: Laroche's letter the *Le Moniteur* refers to the stone plates employed, and the four large presses the firm had in its

workshops. They produced photo-engravings by the photolithography process, as well as having six presses which use the Albertype.

In 1884 Policarpe Joaillier became Sébah's partner. Four years later his name was included in the title of the studio, which now became Sébah et Joaillier, the joint signature appearing on the later photographs. The partnership was dissolved shortly after 1900, when Joaillier returned to Paris. The studio however continued, and still issued photographs with the joint signature. Sébah himself eventually retired in 1908, at the age of seventy. The studio, and its stock, was sold. It continued, under the old name, and in its original premises, until the 1950s. According to Engin Çizgen, a 'large quantity of the photos remaining in the archive' survive, unfortunately deteriorating in the basement of a large Bosphorus house.

Sébah's photographs of Athens have to be dated on internal evidence, and this seems to be conflicting, so it is possible that the photographs were not all taken at one and the same time. The crucial point is again a view of the Theatre of Dionysus (Plate 59), and the state of the archaeologists' hut suggests a date not far removed from Stillman and Bonfils, i.e., *c.* 1870. He also photographed examples of sculpture stored in the Theseum (the temple of Hephaistos) (Plate 87) which served as a depot prior to the opening of the National Museum; when Ludwig von Sybel published his catalogue of sculpture in 1881 the piece concerned – the funeral *stele* (engraved standing stone) of Archestrate – had been moved to the National Museum. On the other hand, another Sébah photograph (Plate 84) is of a piece of sculpture actually in the museum already, and should therefore be later than the opening of the museum in 1874 (unless photographed before the actual opening of the museum, which is possible). But even with these possible variations, Sébah falls into the same chronological position as Sir Lawrence's other main acquisitions of Greek photographs – the first half of the 1870s – which were supplemented by the new series of Stillman photographs after 1882.

There is a copy of another photograph by Sébah in the collection of H. Blackmer which has been reproduced by John Travlos in his *Attike, A Pictorial Dictionary of the Topography of Ancient Attica*. The photograph is a general view of the sculpture kept in the Theseum, which Travlos dates to 1870 – a date in keeping with most of the Alma Tadema examples of Sébah's work.

Despite the complaints Laroche makes in his letter to *Le Moniteur* about the difficulty of obtaining good quality photographic materials in Constantinople, Sébah's photographs are of outstanding quality. They are excellently composed, and totally uniform in dimension, 26.00cm x 34.00cm, presumably the size of the plate he was using. Particularly noteworthy are his photographs of sculpture, especially the series showing those slabs from the frieze of the Parthenon which were then kept in the open against the north wall (partly repaired in brick) of the *cella*. These are of a remarkable clarity: in particular, Sébah has been able to emphasize the details of the relief, even though much of it is extremely shallow,

Fig. 11 The stele of Archestrate, in the Theseum (Sébah, 1870s, Plate 87).

and, in places, worn. These photographs bear comparison with modern photographs taken specially to illustrate the sculpture, and indeed in some respects are superior to them. Comparing the copies of the Sébah photographs made by Graham Norrie with the actual sculpture, now in the Acropolis Museum, was a revelation. Often there were elements of the sculpture which could be seen more clearly on Sébah's photograph than on the stone itself. (A particularly good example is Plate 70, in which the drapery details are rendered with considerable crispness and apparent depth.) This is not simply a matter of the original being in better condition in 1870 than it is now. True, there are places where Sébah's photographs show details of the sculpture which have now totally disappeared; but this is always a consequence of the original having suffered accidental damage since 1870, particularly to the edges and corners of the slabs, presumably when they were moved from the Parthenon into the Acropolis Museum. However, there are other areas which quite clearly have not suffered in any way since 1870, and it was Sébah's ability to use the correct angle of lighting to bring out the detail which was so skilful. This had to be done without any modern aids of artificial lighting and, of course, without being able to move the sculptures at all. He used the shadows to emphasize the highlights, which is how the sculpture 'works'. In this respect it is worth comparing his photograph of a slab from the Nike parapet (Plate 82) with the much flatter, less accentuated photograph (admittedly of a different fragment) by Stillman (Plate 81): both, of course, were taken in the temple itself, where these pieces were then kept.

The major contributor to the Greek section of Sir Lawrence's collection of photographs was William James Stillman. His career is more fully documented than that of most nineteenth-century photographers. His published photographic work is scanty; a sumptuous album, 'The Acropolis of Athens', illustrated picturesquely and architecturally in photography, published in London in 1870 and which contained twenty-six carbon prints produced by the Autotype Company, was his principal achievement. The photographs in this album, together with variants of them and others taken at the same time, were also circulated as albumen prints, and later versions of them, re-photographed in 1882, were sold both as autotypes and albumen prints by the Society for the Promotion of Hellenic Studies in London. The Society's library still possesses many of the glass negatives from the later series, together with one of his earlier negatives. These seem to be the only photographs by Stillman which were sold commercially, the remainder of his work being produced for his own pleasure, or for circulation to his friends. In this way he belonged rather to the circle of gifted amateurs than to the professional photographers of his period. Unlike most nineteenth-century amateur photographers, however, he did not come from a well-to-do background; indeed, the proceeds from his Acropolis album were to rescue him at a time of some financial embarrassment. His career was a varied and fascinating one; fortunately he was persuaded at the end of his life to write his autobiography, and this, together with his other writings,

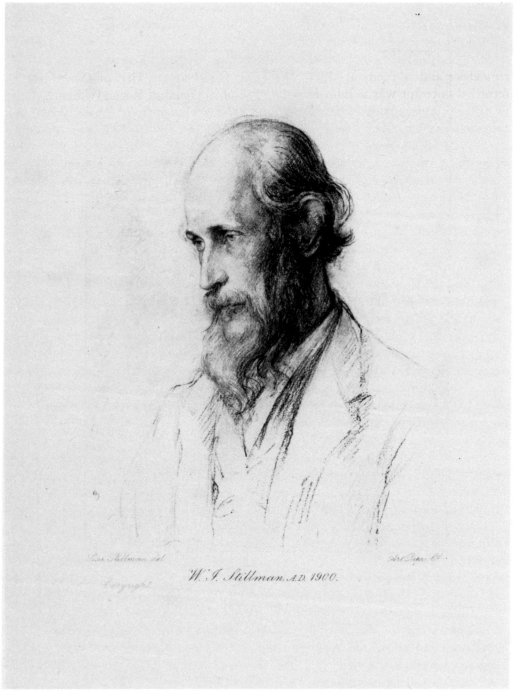

Fig. 12 William James Stillman, from a drawing by his daughter Lisa (frontispiece to Vol. 1 of his autobiography).

provides us with a very detailed and illuminating account of what he did, though with much more detail of the non-photographic aspects of his achievement.

He was born in 1828 in Schenectady, New York. His father's family had migrated to America at the restoration of Charles II 'having had relations with the regicides' and settled at Wetherfield in Connecticut. His mother's 'earliest recorded ancestor was a John Maxson, one of the band of Roger Williams, driven by the Puritans out of Massachusetts into the wilder parts of Rhode Island and Providence Plantations where, in the absence of all established law, as well as government, they might worship God in the way their consciences dictated, free from the restrictions on the liberty of conscience imposed by the Pilgrim Fathers.' John Maxson was one of the group known as Seventh-Day Baptists who held that Saturday, rather than Sunday, was the Lord's Day. One of the Stillman settlers, George, 'having heard of his strange doctrine', went to Newport to convert the Seventh-Day Baptists to more orthodox belief, but was instead converted himself.

The families continued to live in Rhode Island in traditional manner and belief, and although William Stillman's parents moved after marriage to Schenectady, their way of life continued unchanged. Stillman's account of his early life, and particularly of his mother, shows a state of existence which must have changed little, if at all, from that of his seventeenth-century ancestors, with its emphasis on self-sufficiency. His mother 'not only did the daily household duties, including washing and baking, but spun and wove the cloth for the clothes of her husband and children, cut and made them up.' It was a frugal, penurious existence: at one stage 'when resources seemed to have been exhausted to the last crumb' they were saved from starvation only by an unexpected gift from one of her half-brothers of a barrel of salted pigeons' breasts, 'the result of one of those almost fabulous flights of the now nearly extinct passenger pigeons [that is, of course, written in 1901; the passenger pigeon is now extinct] who in that year had chosen the forests in my uncle's neighbourhood for their nesting ground, and had been killed by thousands and salted down for winter provision, only the breast being used owing to the superabundance of the birds.'

Stillman's mother seems to have been the dominant character of the family, and it was at her insistence, and against the inclinations of her husband, that her younger sons, including William, received a college education. Charles, the first brother to graduate, became the college bell-ringer to pay his fees, while their mother took in students' washing; for the youngest brothers, Jacob and William, 'this drudgery was exchanged for that of a students' boarding house'.

Stillman went to Union College in Schenectady, which was, he says 'at this epoch ... the third university of the United States, coming, in the general estimation and the number of its graduates immediately after Yale, Harvard being then, as always, the first; and it owed the character and peculiar reputation to the strong and singular personality of its first president Dr. Nott.. the most remarkable of all the teachers I have ever known.' Stillman was not a brilliant scholar: 'of my

college course, I retained only what held my sympathies. I never went in for honours, or occupied myself beyond the required measure with studies which did not *per se* interest me ... I took my degree, but not with distinction.' Having graduated, he felt free to devote himself to his real interest which was the study of art.

This interest had been awakened when John Wilson, an Englishman who had been a portrait painter at St Petersburg but had abandoned this to try a new life as a farmer in 'one of the Western States of America' in turn gave this up to become a tutor of Pitmans' phonograph (i.e., shorthand) at Union College and had boarded with Stillman's mother. Stillman wanted to be a landscape painter, but found it next to impossible to get adequate tuition in the United States. There was 'not in the United States a single school of art and ... no competent landscape painter who accepted pupils, nor perhaps one who was capable of teaching' (except the self-taught Thomas Cole, who agreed to take on the young Stillman, but died before he graduated from college). Stillman then applied to A.B. Durand, 'then the president of our Academy' who could not bring himself then to accept a pupil, but passed Stillman on to a former pupil, F.E. Church. He, however 'had little imagination and his technical training had not emancipated him from an exaggerated insistence on detail'. Study with Church lasted one month only, and 'showed that nothing was to be hoped for from him'. In Church's studio he learned nothing (though he did meet Edgar Allan Poe). True revelation of the nature of art came from another source which was, in fact, to change the whole course of Stillman's life: he came across John Ruskin's *Modern Painters* and 'like many others, wiser or otherwise', received from it a stimulus to nature worship which made ineffaceable the confusion in his mind between nature and art. Stillman sold a painting to the Art Union of New York, and on the proceeds, thirty dollars, 'the first considerable sum of money I had ever earned, I decided to go to Europe and see what the English painters were doing ... To see Turner's pictures was always the chief motive, and was the one which decided me to go.' He crossed the Atlantic in January 1850 on the Garrick, a packet of the Black Ball line, the passage to Liverpool taking twenty-one days; the voyage was one of the most delightful memories of his life. His own money, translated into six sovereigns, was eked out until he received a letter of credit for fifty pounds from his brother. He then travelled by train, arriving at Euston in the small hours of the morning.

Stillman was armed with letters of introduction, in particular one to S.C. Hall, editor of the *Art Journal*. With these, Stillman was soon able to extend his introduction to other critics, painters and art dealers in London. Reading between the lines of the autobiography, it is possible to perceive just how strenuously Stillman promoted himself. After making the early acquaintance of Griffiths, 'a dealer in pictures who was Turner's special agent', he visited Griffiths' galleries. Here 'I was looking at some early drawings of Turner, when a gentleman entered the gallery and, after a conversation between them, Griffiths came to me and asked

if I should not like to be presented to the author of *Modern Painters*.' Soon Stillman was invited to Ruskin's home in Grosvenor Street where he met several artists, among them G.F. Watts, had an argument with Mrs Ruskin about the merits of bagpipes, and discussions on religion and on art with Ruskin. Later, he met Turner himself, a meeting which according to Stillman could be interpreted as going well; even more significantly, he saw paintings by Rossetti and Millais. It was the work of the latter which influenced Stillman profoundly, and, on his return to America, Stillman's studies from nature gained for him not only election to the Associateship of Design but also the appellation of 'The American Pre-Raphaelite'.

Looking back on this in his autobiography, Stillman sees it all as a mistake. 'The success only confirmed me in my incorrect views of art, and carried me further from the true path.' His painting was in the spirit of the Ruskinian doctrine, of which he had made himself an apostle.

At this point his development as a painter was interrupted by his taste for adventure. Throughout his life Stillman seems to have succumbed to sudden changes of influence and interests which prevented him from concentrating overlong on any single activity, and helps explain the relative paucity of his production, whether, in this early stage of his life, his paintings, or, later, his photographs. The adventure he now undertook was obviously real enough, although his account of it reads more like something from comic opera or popular fiction. It was serious in purpose, though conducted by its protagonists with such bumbling incompetence that its failure is hardly surprising, and Stillman's escape from misfortune a matter of luck.

In December 1851 the Hungarian patriot Kossuth arrived in the United States in furtherance of the campaign to free his country from the Austrian Habsburgs. He found in the American love of freedom considerable, if ill-founded, support; and Stillman, in what now seems clearly his predilection for hunting big names, made his acquaintance and was soon in the habit of going to see him at night. A Democratic committee promised Kossuth two ships of war and half a million dollars in return for his support of their candidate for the presidency. Stillman was to gather a deposit of arms and materials of war at a point in the Mediterranean from which Kossuth could descend promptly on the coast of Croatia. The point chosen was the island of Galita, south of Sardinia, unoccupied and it seems unclaimed by any power, but on which Kossuth told Stillman the flag of the United States had been hoisted some years before, apparently as a joke. This scheme came to nothing; instead, Stillman was sent on an equally ill-prepared scheme to retrieve the crown of St Stephen, which had been concealed by the insurgents in the Hungarian rising of 1848. A coded message was concealed in the hollowed-out heel of one of Stillman's shoes. With this, Stillman travelled to Vienna and thence to Budapest, where his task was to recruit an agent. But the contacts were unsatisfactory, being already suspect to the police; Stillman's attempts to find suitable contacts caused him much walking, and the hollowed heel of his boot was

beginning to wear away. In the end, unheroically, Stillman threw the coded message down the sink, and returned to London. The whole episode seems to have been a complete farce, but this was hardly Stillman's fault; and through it his American love of freedom, and sympathy with the oppressed, stands out.

From London Stillman moved to Paris, and resumed his artistic activities, where again he soon made the acquaintance of the leading names of the time. He worked in the *atelier* of Yvon, director of École des Beaux-Arts. Here he stayed until his money ran out, and a friend of his brother arrived with an order for a free passage home to the United States on a steamer of which he was part owner.

After a nasty accident with an icy snowball, as a result of which the bone enclosing his front teeth had to be removed, Stillman went to a farm of an uncle to paint a wooded scene, very Ruskinesque from his description of it, 'a little spring under a branching beech and surrounded by mossy boulders'. It was exhibited at the Academy Exhibition and aroused much interest, but did not find a buyer at its price of $250. It was so thoroughly realistic that 'the stones seemed not to be painting, but the real thing', and the picture gave rise to a lot of discussion when exhibited, 'the old school of painters denouncing such slavish imitation of nature'. This led to an unexpected development. Stillman goes on, 'As the negative photographic process had just then been introduced in America, I had the picture photographed, and a friend took a print of it to the head of the old school, without any explanation. My antagonist and critic looked at it carefully, and exclaimed "What is the use of Stillman making his Pre-Raphaelite studies when we can get such photographs as this?"'

His craving for adventure led him to spend the summer living wild in the then primeval Adirondack Forest, in the northern part of New York State. The area was little known or visited, and here Stillman hoped to find new subjects for art, spiritual freedom, and a closer contact with the spiritual world. He painted and fished but his quest was an illusion, his fellow backwoodsmen, far from being spiritually free, having taken to drink; all the same, Stillman passed a very happy summer, enjoying his work and wandering in the forest.

On his return to New York he took a studio, and continued his landscape painting; but in addition he obtained the position of fine-art editor of the New York *Evening Post*, thus beginning, almost as an off-chance, what was to become his most consistent career, that of a journalist. From this he developed the idea of a weekly publication devoted to art. He went into partnership with John Durand, son of the president of the National Academy of Design, who succeeded in raising the necessary capital, with Stillman's brother Thomas as security for half of the sum. Stillman's aim was financial: he was now feeling the need to earn his living, and hoped the weekly (which was called *The Crayon*) would furnish him 'with sufficient income to follow my painting without any anxiety as to my means of living'. To raise support he went to Boston and Cambridge, where he met with a cordial response from some of America's leading intellectuals – Lowell, Henry Wadsworth

Longfellow, Charles Eliot Norton, R.H. Dance, Agassiz, Emerson and others – most of whom were soon contributing articles and poems to the paper (and showing their support by refusing to accept fees for their work when it was printed). The paper was a public success, and soon had a subscription list of 1,200, but commercially it was a failure; Stillman was overworked, he lost money, and with the conclusion of the third volume, at the end of eighteen months, he broke down and had to give up the work.

Stillman gave up his studio in New York, went to Boston where he executed his commissions, and then moved to Cambridge. Here he made his home, spending the late summer in the Adirondacks, taking with him his Cambridge friends. This semi-formalized itself into the Adirondack Club, which purchased a substantial area of the forest for its established camp; only Eliot Norton and Longfellow did not participate. Stillman devotes several chapters of his autobiography to his companions of the Adirondack Club, of which by 1901 he was the last survivor; even the wilderness itself had gone when he wrote. Stillman himself fell ill, having developed pneumonia in a snowstorm in the Adirondacks, and was ordered off to Florida to recuperate, at the expense of Charle Eliot Norton.

It was at this point that yet another pursuit entered Stillman's life. 'Being advised not to occupy myself with painting while there, I bought a photographic apparatus, and learned photography as it was practised in 1857, a rude, inefficient and cumbersome apparatus.' Stillman gives a fuller account of his introduction of photography in an article published in the *American Annual of Photography* in 1891. He took up photography as a means of bringing back records of vegetation, when he had been forbidden to paint. He purchased his equipment from Black, of Whipple and Black of Boston, and had two lessons of half an hour each to learn the process. He had bought a whole-plate box of the old kind, a telescopic arrangement with one slide, a Jamin lens of Benjamin French, a long-focus portrait combination, a *gutta percha* bath and a lot of glass and chemicals.

The summer of 1859 he took his photographic apparatus to the Adirondack Camp; sixteen of his photographs were issued by Whipple and Black in an album, *Photographic Studies by W.J. Stillman, Part I. The Forest, Adirondack Woods*, and a folio of these was distributed to each member of the Adirondack Club.

Later that year Stillman returned to England. He brought with him one of his Adirondack paintings, the 'Bed of Ferns', and one or two smaller studies. He took lodgings in Charles Street, Middlesex Hospital, and worked at his painting. He was visited, he tells us, by Dante Gabriel Rossetti, Frederick (later Lord) Leighton ('Then in all the glory of his Cimabue picture, and the promise of an even greater career than he finally attained'), Sir John Everett Millais, and Val Prinsep. (The latter, a nephew of the famous photographer Julia Margaret Cameron, had gone with G.F. Watts as artist on Charles Newton's archaeological expedition to Budrum and the excavation of the Mausoleum there, where their artistic achievements as recorders of the work and discoveries had been completely superseded by

the photographer Corporal B. Spackman of the Royal Engineers.) Rossetti was interested in Stillman's painting and 'expressed himself in strong terms of praise'. Ruskin, however, was not so impressed and 'in a tone of extreme disgust, pointing to the dead deer and man in Stillman's masterpiece said, "What do you put that stuff in for? Take it out; it stinks!".' So Stillman did; but when Rossetti next visited he asked with a look of dismay what he had done to his picture. Stillman explained that on Ruskin's advice he had painted out the figures. Rossetti exclaimed 'You have spoiled your picture' and walked out of the room in a rage. Stillman, however, still had faith in Ruskin's judgement, and though the ruined 'Bed of Ferns' was rejected by the Academy, he accepted an invitation to accompany Ruskin to Switzerland. Stillman enjoyed the Alps and Switzerland, but 'as might have been expected' he and Ruskin agreed neither in temperament nor in method. Stillman sketched and painted but 'we still spent our evenings in discussion and arguments . . . and the steady strain, with my anxiety to lose none of my time and opportunities, finally told on my eyes.' One day, while working hard on the view of Neufchâtel, 'I felt something snap behind my eyes, and in a few minutes I could no longer see my drawing.' After a temporary respite, the trouble returned. 'My summer with Ruskin, to which I had looked for so much profit to my art had ended in a catastrophe.' It took Stillman two years to recover.

He recuperated in France – resisting an opportunity to assassinate Napoleon III!: 'I was at St Martin when the Emperor and Empress made their tour through the new possession [Savoie] . . . They had to wait about half an hour . . . under my window, beside which stood my loaded rifle. I thought how easily I could change the course of European politics, for I could have hit any button on the Emperor's clothes, and ·I hated him enough to have killed him cheerfully, as an enemy of mankind.'

Stillman had been engaged for some time to Laura Mack, the elder daughter of Dr David Mack, 'with whom I had been boarding when I was occupied in painting the various pictures of the Oaks at Waverley', before his last visit to England. Stillman was about to join Garibaldi when he received a letter from Dr Mack 'telling me her perplexities and distress of mind over our marriage had so increased that they feared for her reason if she were not set at rest'. So he took the next steamer home and ended the vacillation by insisting on being married at once: 'Nothing but a morbid self-deprecation had prevented her from coming to a decision long before, and there was no other solution than to assume command and impose my will.' Undoubtedly Stillman's wife suffered from mental disturbance; and whether such an unsettled man as Stillman was the right husband for her is debatable. Certainly the circumstances of her husband's next career were to impose such a strain on her that she committed suicide.

After the wedding, Stillman with his new wife returned to Paris where they made the acquaintance of Robert Browning, his parents and his sister. He then returned to America, intending to volunteer to join a regiment of Massachusetts troops, fighting for the Union (which Stillman of course supported) in the American Civil

War, only to be turned down because of his ill health. Instead, Stillman travelled to Rome via England, leaving his wife, who was pregnant, at home in America. Stillman served as US Consul to Rome (which was then still a Papal State) from 1862 to April 1865. For this he did not receive a salary, but was paid by a system of fees. Since he was now married, and had a family, he supplemented his income by journalism, and this was to remain perhaps his most constant and certainly most productive source of income. It was soon sufficient for him to bring his wife and their son, John Ruskin Stillman, to join him in Rome. He seems to have been a success as consul, getting on well with the Pope, Pius IX, despite his own Puritan background. In Rome he had to represent the interests both of the north (to which he belonged by both his own birth and birthplace, and, more particularly, his liberal sympathies) and the south (so US citizens from the south had to swear allegiance to the Union to obtain the renewal of their passports). He was able to secure permission for the opening of a church for a Protestant congregation, hitherto excluded within the walls of Rome. He continued to take photographs while in Rome, and purchased new photographic apparatus there. His new camera was 'an 8 x 10 Kinnear, the *ne plus ultra* of that day, with a 15 inch landscape lens'.

By this time he had been appointed US Consul in Candia, the old-fashioned name by which the American authorities still referred to Crete. The Consulate itself was at Canea, not at Candia (the Venetian name for Heraklion). At this time Crete had been excluded from inclusion in the new state of Greece by the settlement imposed by the Great Powers that ended the Greek War of Independence, and it was still part of the Ottoman Empire, although Turks formed only a minority of its population. Compared with Rome it was a backwater, and the involvement of the United States in its affairs was minimal. One wonders why Stillman chose to go there; perhaps the attraction was that it carried a regular salary, even though this was only $1,000 per annum (having been recently reduced from $1,500). However with this went permission to engage in business, which enabled Stillman to continue to write his journalistic pieces, contributing to the *Atlantic Monthly* and *The Nation* in particular. He was responsible for writing his own reports to the US Secretary of State, W.H. Seward, but the prospective burdens of the Consulate were slight, the number of American visitors to Crete few in the extreme, and trade (which Stillman conscientiously did his best to foster) minimal. No doubt he looked for a comparatively leisurely life, with time to pursue his own interests. For a while he painted, and wrote, and photographed, as he visited different, often remote, parts of the island. Several of his photographs from the Cretan period survive: some were collected by the captain of a French ship, the *Salamandre*; others were acquired by the Rosettis, William as well as Dante Gabriel. There are interesting parallels between Stillman's travels and photographic productions and those of Edward Lear, whose journey to Crete took place the year before Stillman arrived. Lear's sketch of the harbour of Chania is recalled by Stillman's photograph.

Stillman seems more enthusiastic for Crete than Lear had been; and his description of an excursion to Platania Gonia and Kissanis, published in the *Atlantic Monthly* Volume XXI (1868) is, on the surface, idyllic. But even this reflects the tensions which were building up in Crete, and which were to lead to the outbreak of full-scale rebellion by the Greeks, and savage attempts by the Turkish governor and his successors to suppress it. Stillman's sympathies are clearly with the oppressed, the Greeks. Of the other consuls, only those of Greece and Russia supported his attitudes. The politics of the Crimean war still lead the British and French consuls to support the Turks. Stillman, in his reports to Seward, called for American intervention, perhaps to take over the island as an East Mediterranean base (Suda Bay, with its superb anchorage, being the attraction) or at least to relieve the increasing suffering of the Greek population, and the starvation with which they were afflicted. The response from Seward was negligible; but the Turkish authorities, becoming aware of Stillman's sympathies, restricted him more and more. In the end, an arrangement to evacuate the Cretan women and children was permitted, but the struggle for independence continued. The monastery of Arkadhi visited by Lear in 1864 was defended against the Turks in December 1866 and, when it was about to fall, and the Turkish forces had burst into its courtyard, was blown up. The strain on Stillman, and his wife and family, was considerable. The cost of food increased continuously, till he could not make ends meet on his meagre salary. The frustration caused by lack of success in bringing relief to the Greeks told, both on Stillman himself, and even more on his wife. In the late autumn of 1868 he took his family to Athens, where there were by this time considerable numbers of Cretan refugees, many of them housed in the old University building on the north side of the Acropolis. At this point, his wife's mind became completely deranged, and she committed suicide as a result of the hardships they had experienced in combination with what seems to have been her inherent mental instability. 'The anxiety and mental distress of our Cretan life, and her passionate sympathy with the suffering Cretans, even more than our privations and personal danger, had long been producing their effect on her mind, and the weaning of the baby precipitated the change into a profound melancholy, which became insanity accompanied by religious delusions, from which she sought refuge in voluntary death.' She was given a public funeral by the Greek government. Stillman returned to Canea. In June 1869 he was relieved of the office of Consul; he transferred the Consulate to his successor on 19 July 1869, and, in his last despatch to the Secretary of State, now Hamilton Fish, said that he would at once leave for Athens to make the preparations for his return to the United States.

Not only was Stillman's wife dead; he now knew that his oldest child, his son John Ruskin Stillman (Russie: John Ruskin was his godfather) was suffering from tuberculosis, and did not have long to live. He did not return to the United States. Instead, he remained in Athens and took the superb series of photographs from

which he selected plates for his album *The Acropolis of Athens, illustrated picturesquely and architecturally in photographs*. The album is dedicated to Miss Marie Spartali, 'worthy scion of the race which has given us the world's consummate art'. Subsequently, Stillman married her.

Marie Spartali provides another link with art and photography. Her father was the Greek Consul in London, and Marie's outstanding (and, presumably, somewhat exotic) beauty as well as her own artistic skills and interests brought her into the circle of Rossetti and the Pre-Raphaelites. She was one of the Pre-Raphaelite models (she was Rossetti's Fiametta, Dante's dream), and, through the same artistic links, also a model for the photographer Julia Margaret Cameron. Stillman may have continued to paint at this time of his career; Marie certainly did, and three of her paintings, all done after her marriage (and signed with a monogram which seems based on that used by Stillman to sign his photographs) were exhibited in the 1989 exhibition at the Barbican in London on 'The Last Romantics': These paintings are dated 1883, 1889 and 1898. (The catalogue to that exhibition knows nothing of Stillman's own artistic achievement, or indeed, his photography, taking him at his own autobiographical evaluation as a journalist.) There is, of course, a divergence: the Pre-Raphaelites had broken away from the Ruskinian emphasis on realism, followed by Stillman in his paintings, into the form of medieval romanticism with which the movement is normally credited. This was the style of Rossetti, and the style of Marie Stillman; for her husband, perhaps, the pursuit of realism was something better achieved with the camera.

The marriage seems to have been a happy one; it must have helped Stillman overcome the anguish of the death of Russie in 1875, one of the most poignant passages in the autobiography. Though Stillman tells us about his first family, he does not mention the other children born in his second marriage. For a while Marie's father was wealthy enough to support his daughter and her husband. Stillman spent much time in London, and during this period in the early 1870s, Sir Lawrence Alma Tadema acquired the first series of Stillman photographs. Although Ruskin had mocked some of Sir Lawrence's painting (with no effect comparable with that of his criticism of Stillman – Sir Lawrence seems to have been much tougher in that respect), and the Pre-Raphaelites formed their own distinctive circle, it seems impossible that Sir Lawrence did not know Stillman; if he did, the acquaintance is likely to belong to this period.

Throughout these years Stillman made a haphazard career. He contributed to the *New York Tribune*, as well as *The Nation*, and he had hopes of becoming the London correspondent of *The Herald*, but that came to nothing. The outbreak of anti-Turkish insurrection in Herzegovina in 1875 must have renewed in Stillman the sympathies which were obvious during his Cretan consulship. He made an agreement with *The Times* that he would go to the Balkans to cover the war, as a freelance, and this was accepted. By August he was at Trieste, and from there he went to Herzegovina itself and to Montenegro. The autobiography now devotes

several chapters to the war which followed. Afterwards he went to Greece, and after that, to support the artistic interests of his wife, decided to settle in Florence (having renewed his acquaintance with Robert Browning, and made the acquaintance of Gladstone). His next venture was to the Aegean, commissioned by Scribner's 'to make an archaeological and literary venture in Greek waters' whch again turned into journalistic work, a series of articles subsequently re-published as a book called *On the Track of Ulysses.*

During this period he at last returned to Crete (where he found a Christian governor, his old friend Photiades Pasha, and a new, intelligent and sympathetic British Consul, Humphrey Sandwith). No excavation was achieved, but Stillman was advised to return the following year, with the support of the American Archaeological Institute. Permission to excavate was requested from Constantinople, apparently with the backing of Photiades Pasha, and when Stillman's assistant, Mr Haynes, 'who had been sent by the Institute to take his first lessons in archaeology and photography' arrived, they both went to Candia 'to select our site'. The result was one of the might-have-beens of archaeology, and is the reason why Stillman is known to present-day archaeologists who specialize in Crete (and is to them more important for this than for his photography). 'We decided', writes Stillman 'on attacking a ruin on the acropolis of Gnossos [i.e., Knossos] already partially exposed by the searches of local diggers for antiques. It had a curiously labyrinthine appearance, and on the stones I found and described the first discovered of the characters, whose nature has since been made the subject of the researches of Mr Evans.' Thus Stillman nearly became the discoverer, rather than Sir Arthur Evans, of the Palace of Minos at Knossos; but behind his back Photiades Pasha was recommending the Turkish authorities not to allow him to excavate. It would have been interesting, quite apart from anything else, to have seen Stillman's photographic skills used in an excavation of his own, but the whole plan, and an alternative to excavate another site – the Cave of Zeus on Mount Ida – came to nothing.

Surviving an attack of typhus at Athens, he went to Volos which had been annexed by Greece – all this time acting as a correspondent for *The Times* – and then returned once more to Florence, which remained his principal place of residence for another five years. It was during this period in 1882, that he returned to Athens to repeat his earlier series of photographs, although this is not mentioned in the autobiography at all. The constant recurrence of fever at Florence drove him eventually from a place where he spent, on his own description, the most tranquil and happiest years of his mature life. He then spent one more year in New York, on the staff of *The Evening Post.*

It was at this point, in 1886, that his wife's father became involved in financial embarrassments which meant he could no longer provide the Stillmans with the allowance which, reading between the lines, had been their only stable source of income during their marriage. At last Stillman had to find a permanent post, and

was fortunate enough to become the established correspondent of *The Times* in Rome, with responsibility for Italy and Greece. Here he remained, still taking photographs for his own interest, until he retired in 1898, at the age of seventy. Following his retirement the Stillmans lived in Surrey, where he wrote his autobiography. He died on 6 July 1901.

The first series of Stillman photographs sold well – particularly the album, which earned for him a sum as large as his annual salary as Consul in Crete. The carbon prints of the album (but not, of course, the cheaper albumen prints of the Alma Tadema Collection) are not all straightforward, but are at times combinations of two negatives, one exposed for the architecture, the other for the clouds, the latitude of the wet collodion plates being inadequate to capture both simultaneously.

In the preface to the album Stillman says that only one such photograph was retouched, but in the copy in the J. Paul Getty Museum this has been altered by Stillman himself to 'four'. There is no denying the dramatic quality of this process, and, of course, the resulting carbon prints are far more durable than the cheaper albumen prints. Yet at times they appear over-dramatic; and too dark for the clear light of Athens. The more balanced contrast on the albumen prints, when copied and reprinted on modern paper, reproduce more naturally than the carbon versions, even if the result is less in accordance with Stillman's artistic concepts. (This is particularly noticeable in plate 18 of the album, where the Acropolis is framed with a bank of clouds – surely, here, added from another negative – which is totally absent in the albumen print of the Alma Tadema Collection – Plate 32 in this book.)

The photographs contain records of Stillman's misfortunes. Plate 3 (in both the album and here), seemingly just a general view of Athens with the Acropolis in the background, includes under the slopes of the Acropolis and clearly standing out above the rest of the town, the building which was once the original University of Athens, and which in 1868–9 was used to house refugees from the Cretan uprising – a reminder of the circumstances of his first wife's death. Plate 30, the eastern façade of the Parthenon, shows Stillman's son sitting on one of the fallen blocks. At this time Russie was mortally ill with tuberculosis; he died in 1875. In 1882 Stillman repeated this photograph, with the same fallen block of stone as its centre-piece.

Stillman made a particular point of illustrating the architectural quality of the ancient monuments. He points out in his introduction to his album that the photographs are all produced with Dallmeyer's rectilinear lenses, and the façades, as far as practicable, are photographed from points equidistant from the extremities. He emphasizes that in making the prints he has seen that nothing should injure the outlines, or diminish the architectural accuracy of the views (though it will be seen that there is a certain amount of distortion, particularly in the angles of the buildings, and the edges of some of the photographs). Inevitably, there were

Fig. 13 Stillman's son Russie, on the Acropolis at Athens (an enlargement from Plate 30).

difficulties in controlling what appears on the negative plate, which, as is exemplified by the one surviving negative of the 1869 series, was printed entire. The negatives of his later series, however, which mostly survive in the library of Hellenic Society, have only selected areas printed.

Stillman certainly made more photographs than appear in the album. Gary Edwards has noted sequences of the same view, the different timing being apparent only in the movement of the shadows which show the passing of the day. The prints in the Alma Tadema Collection, and others, vary at times from those in the album, and include subjects which were rejected altogether. There also seems some variation in the albums themselves, though since the photographs were mounted in them on separate sheets of card, and not bound together in book form, it is possible that the individual photographs have been lost. No. 6a (9793; Plate 9 in this book) occurs in one album in the Gennadeion Library at Athens, but is apparently not in the album in the J. Paul Getty Museum. The Gennadeion copy does not have No. 7a (Plate 12). No. 13 (Plate 25), for which by chance the negative

survives, is not used in the albums at all, where Plate 13 is of a completely different view. No. 26 (Plate 68) is not in the album, which ends with No. 25 (Plate 69).

Stillman is careful to reveal the details which are part of the qualities of Athenian architecture. He includes, obviously, conventional views taken on the axis of the façades of the Parthenon, but he also takes several photographs which deliberately avoid securing full views to concentrate on sections of the architecture. In photographing the Propylaia (Plates 7 and 9) he ignores the Frankish tower, which appears as a partial element of extraneous construction to the side of the classical building. His view of the west portico of the Parthenon ignores the upper parts of the columns in the foreground, but gives us the receding lines of the sequence, and the pattern of shadows on the paving which would have been the same when the building was intact. He shows the outline of columns against the sky, revealing their entasis, and he shows views of the steps which emphasize the curvature: obviously he knew F.C. Penrose's monumental study of *The Principles of Athenian Architecture*, and here he is demonstrating the value of photography, for though Penrose makes clear in his architectural drawings what the refinements are, they are much more successfully revealed by the camera.

Stillman's photographs are far from being the earliest of the Parthenon, but they are the first deliberately to demonstrate the distinctive characteristics of the Classical form. Here, it may be agreed, lies their particular value to Sir Lawrence Alma Tadema. In the early 1860s he had made his painting of Pheidias from the section of the Parthenon frieze in the British Museum: now, with Stillman's Plate 17, he has a view of it *in situ*, and without having to follow Stillman up the steps of the bell-tower and across the surviving ceiling beams on to the top of the outer entablature.

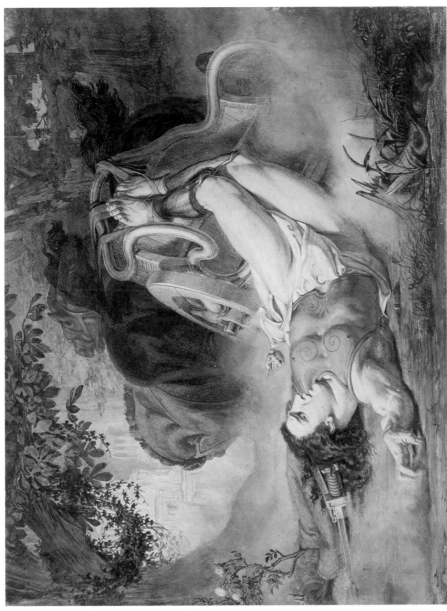

The Death of Hippolytus. Watercolour of 1860 (opus XIII). (Listed as the death of Hippolyte in Vern Swanson's catalogue, a faulty translation from the French title, *La Mort d'Hippolyte*.) The earliest painting on a Greek theme, this picture shows, exceptionally for Sir Lawrence, a scene from Greek mythology, the death of Hippolytus, son of Theseus (and nephew of Hippolyte, who was the Queen of the Amazons).

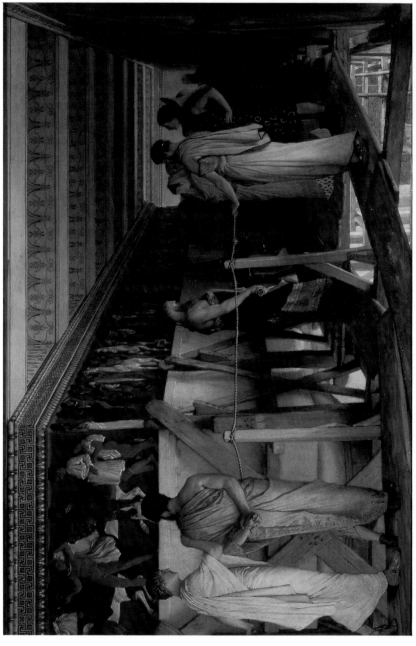

Pheidias and the Parthenon, 1868 (opus LX). A 'reconstruction' of an invented 'viewing' of the Parthenon frieze by the Athenian politician who instigated the building of the temple. An early example of authenticity based on the actual sculpture (the Elgin Marbles in the British Museum) and nineteenth-century ideas, such as those of F.C. Penrose, on the use of colour in ancient sculpture and architecture.

The Pyrrhic Dance, 1869 (opus LXIX). The painting derided by Ruskin as 'a small detachment of beetles looking for a dead rat'. The Pyrrhic dance was a classical Greek martial dance. The armour (shield and greaves, as well as the spears) is based on authentic representations, though the action of the dance is Sir Lawrence's own idea.

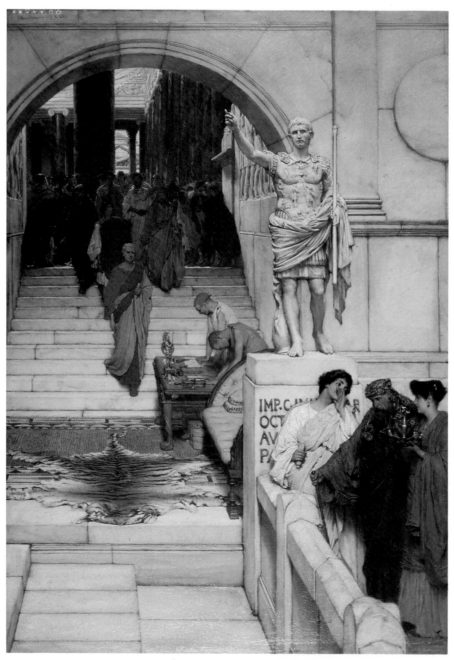

An Audience at Agrippa's, 1876 (opus CLXI). A Roman, not a Greek subject, this picture is interesting for the meticulous copying of the 'Prima Porta' statue of the Emperor Augustus, then recently discovered.

Xanthe and Phaon, 1882 (opus CCLIX). There appears to be no historical or mythological significance in this painting – it is just a picture. The names seem taken at random from a dictionary: Xanthe is a daughter of the Ocean and Tethys, and so the personification of a river. Phaon, a ferryman of Lesbos, made irresistibly attractive to women as a reward for transporting Aphrodite, disguised as an old woman, free of charge. Sappho is supposed to have fallen in love with him. Equally random are the names inscribed on the stele (Lysander was a Spartan general of the late fifth century). The stele is based on the Athenian examples in the collection of photographs (note particularly the form of the gable crown, compared with plate 87, the stele of Archestrate): the elongated shape of the sculpture on it, however, is not authentic.

The women of Amphissa, 1887 (opus CCLXXVIII). This depicts female worshippers of Dionysus, exhausted after the ritual dancing, for which Amphissa in Phocis, not far from Delphi, was a centre. The architectural background, however, is derived from the photographs of the Athenian Propylaia in Sir Lawrence's collection, though it is *not* a precise copying of the Athenian building.

A dedication to Bacchus, 1889 (opus CCXCIII). A totally imaginary scene, but using authentic elements (the form of the altar, the silver mixing-bowl or crater).

Silver favourites, 1903 (opus CCCLXXIII). The semicircular marble seat (an exedra) is of a type found in Greek sanctuaries; by the time this picture was painted numerous examples had been published in excavation reports in books which were in Sir Lawrence's library. The pool, on the other hand, is not something which would have been associated with such a marble seat.

THE PHOTOGRAPHS

The photographs have been grouped by subject. It was tempting to arrange them according to the photographer, since then it would have been possible virtually to recreate Stillman's *The Acropolis of Athens*, which certainly dominates the collection. This however would have made it difficult to relate the work of the other photographers, as well as the later photographs by Stillman himself. Nor is there much point in a chronological sequence, since the difference in date between early Stillman, Bonfils and Sébah is not of any great consequence, while this would have the effect of separating early Stillman photographs from his later versions. On the other hand, it would seem that the original sequence of presentation in Stillman's *The Acropolis of Athens* was carefully designed, to lead *into* the monuments, as it were. He begins with the Beulé gate on his title page, symbolizing the entrance to the whole work. He then gives distant views of the Acropolis from different directions; from west, south-east, north, north-east as well as the closer view under the walls of the Acropolis rock and from the theatre, before taking us on to the Acropolis itself. I have broadly followed this pattern: first, the distant views of the Acropolis and the nineteenth-century town, followed by the general approach on to the rock itself, by way of the entrance gateways, to the temples. Then a section on the other ancient buildings, including the theatre on the slopes of the Acropolis, and others further away. That is followed by the photographs of sculpture, and then, to conclude in an ancient chronological sequence, the Byzantine remains, which Stillman, of course, ignored.

In the following section, the captions printed in italic at the head of each description are those written – mostly, it would seem, by Sir Lawrence – on the mounting card of the photograph concerned. Those of the 1869 photographs by Stillman are taken (with Sir Lawrence's original mistakes) from *The Acropolis of Athens*. Original inaccuracies are retained. Dimensions are given in centimetres throughout.

1. STILLMAN, 1869

The Acropolis, from the hill above the Ilissus, looking north-west. At the extreme left the Museum hill with the monument of Philopappus.

This shows the Acropolis viewed from the hill of Ardettos, near the Stadium and looking from the south-east. The foreground consists of the platform of the temple of Tyche, built by Herodes Atticus in the second century AD.

According to Professor Christos Doumas (in conversation), vestiges of the windmill still remained until very recently (although this area is now inaccessible to the general public). Beyond the walls, to the right, is the precinct wall of the Sanctuary of Olympian Zeus, unexcavated and unrestored. The temple itself is in the same state as it is to be found over a century later (the third column between the two to the west stood until the gale of 1856 and can be seen still standing in one of the calotypes by Alfred Normand of 1851/2). On the architrave, above the westernmost column of the main group, are the remains of a later structure, apparently a hermit's hut. Beyond the temple, modern Athens has not yet extended beyond the line of the eighteenth-century Turkish walls of Hasebi, though these had been demolished immediately after the War of Independence to form the Boulevard of Queen Amalia. The large building at the southern end of the town is the Military Hospital of 1839 (now restored and refurbished for the Archaeological Service as its Acropolis Centre). Across the road the Theatre of Dionysus can be made out, and beyond this the line of Turkish fortifications leading up to the stoa of Eumenes (incorporated into the Turkish walls), the Theatre of Herodes, from which the Turkish wall (the Serpentze) leads to the Acropolis and the prominent Frankish tower. Note also the tips of demolition debris at the side and end of the Acropolis rock.

Plate 4 in *The Acropolis of Athens*.
Catalogue no. 9780.
24.00 x 18.00.

Note

These are the standard dimensions followed more or less exactly in all Stillman's 1869 photographs, and they correspond to those of the original negative, as the one surviving negative (9888; Plate 24) shows.

2. STILLMAN, 1869

View taken from the tower of the Cathedral, looking south-west.
Mars hill [i.e., the Areopagus] *is seen to the right of the*
Acropolis. (Fig. 4, p. 8)

Stillman's lens rather distorts this long-distance view of the Acropolis, which in reality is much closer, and much more dominating over the buildings of old Athens.

The buildings in the foreground facing on the Square of the Metropolis (the nineteenth-century cathedral of Athens, from which the photograph was taken) have been replaced by modern buildings, but otherwise the general appearance of the old town of Athens has not much changed. The street running diagonally from the left and the related demolitions is an extension of Apollo Street. This was part of the 'tidying up' of the old street plan of Turkish Athens and served to link it with the new city with its straight streets laid to the north.

The building in the left foreground is on top of the line of Venizelos Palaeologus Street, one of the new roads which were designed to improve the alignments in the vicinity of the cathedral, still not completed in 1869 (though Apollo Street, into which it leads, has been made). It appears that demolition work is in progress in connection with this. The new building on the side of Apollo Street (whose angled front marks the junction of the new road with an existing street of the old town) has gone, but its modern replacement has the same angle to its façade. Beyond this, largely concealed by the blank building on the near side of Apollo Street, is No. 98 Hadrian Street, one of the surviving houses of Turkish Athens and perhaps the oldest: its roof is just visible in this photograph.

Plate 5 in *The Acropolis of Athens*.
Catalogue no. 9781.
24.30 x 18.80.

3. STILLMAN, 1869

View of the Acropolis from the north with the Turkish town at its foot. At the extreme right is the Muses hill and the grotto of Pan nearby under the square tower.

Stillman took this photograph from the upper floor or the roof of a building at the corner of Athena and Hermes Streets, two of the new straight roads which were part of the new plan of Athens created after the War of Independence. The church in the foreground is the tenth-century Pantanassa, the little monastery (*Monastiraki*) which gives its name to the district. The bell-tower has now gone, to be replaced by a more ornate structure at the side of the church, but otherwise the church, though badly restored, is essentially unchanged. So too is the mosque behind it, the mosque of Tzistarakis, known as the mosque of the Lower Fountain, built in 1759 by the Voivode (the Turkish Governor of Athens) whose name it took; it has recently been repaired and redecorated. In Stillman's photograph this conceals the surviving part of the west façade of Hadrian's Library; beyond that the visible large light-coloured building is the former residence of the Voivode, built in the second half of the eighteenth century and in Stillman's time used as a barracks. It survived until 1931, when it was demolished; pieces of its walls can still be seen in the new excavations of Hadrian's Library. The rest of Hadrian's Library is concealed largely by the gaunt structures to the side of the mosque, more of the Turkish adminis-

trative buildings; and to the side of that, marked by the prominent clock tower, is the bazaar, which dates back to the time of the Turkish occupation, and at the time of this photograph was still functioning as the principal market area of Athens. The tower, which stood by the remains of the Church of the Great Panagia, was built by the city to house a clock given by Lord Elgin in 1814 and promised to the Turkish authorities if he was allowed to remove the Parthenon sculptures. The clock was destroyed in the War of Independence and the tower converted into a prison. The clock visible in the photo is a replacement of 1848.

The whole of the bazaar area, including the clock tower, was destroyed in a great fire in 1885. The site was then purchased by the Archaeological Society and excavated in accordance with the original plan for the renewal of the city after the Liberation, which envisaged the whole of this area being turned into an archaeological park. Just visible above the roof of the long building behind Elgin's clock is the roof of the Tower of the Winds. To the right and higher up (the last building before the slopes of the Acropolis) is a substantial two-storey house with a veranda supported on four piers. This is the Cleanthes house, the old University building, which still survives. It dates

back to the Venetian occupation of Athens, and functioned as the University from 1837–41. In 1869, when Stillman took this photograph, it was being used to house refugees from the Cretan insurrection, and must have been a poignant reminder to Stillman of the difficult days of his consulship in Chania, and their distressful consequences for him.

The photograph shows the way this side of Athens is dominated by the Acropolis, whose ancient buildings are less prominent here than they are today, largely because of the demolition of the nondescript later fortifications on the north side (the height of which can be seen in Plate 45, Catalogue no. 9839). The square tower is the tall Frankish tower, not yet removed from the south-west wing of the Propylaia. The monument of Philopappos can be seen faintly on the Hill of the Muses.

The 'grotto' beneath the tower is not the Cave of Pan, as described by Stillman, which is now known to be situated at the eastern end of the Acropolis. In 1869 the real cave was totally concealed behind a mass of debris (which can be seen in Plate 1) tipped over the side of the Acropolis during the cleaning operations carried out after the Turkish garrison had left.

Plate 3 in *The Acropolis of Athens.*
Catalogue no. 9778.
24.00 x 19.00.

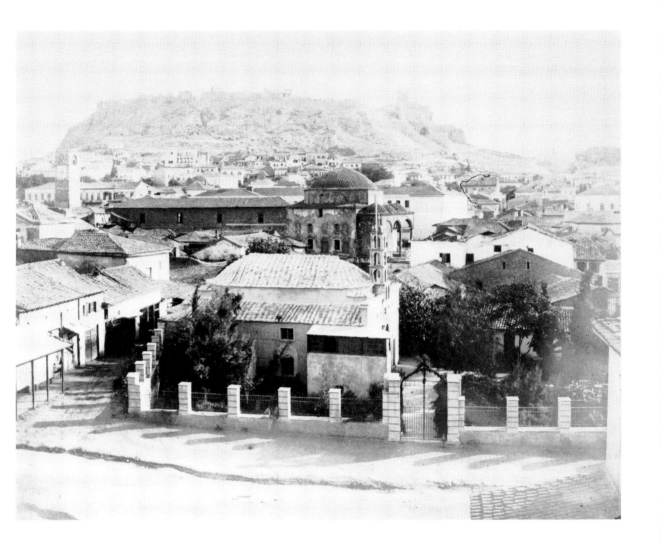

4. STILLMAN, 1882

(This is a repeat of No. 1 of the 1869 series, which is not
in the Alma Tadema Collection.)

The 1869 version was titled 'View of the Acropolis from the Museum Hill. A portion of modern Athens is visible at the left. At the right is seen the course of the Ilissus and the remaining columns of the Temple of Jupiter, beyond which rises Mt. Hymettus. The view is eastward.' In the later photograph all this should be visible, but the Alma Tadema print is rather faded, and the distant parts, the town and the temple of Jupiter (Olympian Zeus) cannot be made out clearly. There is little obvious change, apart from the removal of the Frankish tower. The building by the modern road has been enlarged, and the rectangular building to its right is new. More importantly, the heap of spoil beyond this is much larger than in the previous version, while the tips that had been prominent down the south side of the Acropolis since the earliest photographs have been removed: this marks the renewal of excavation work on the slopes of the Acropolis, and made possible the discovery of the sanctuary of Asklepios (No. 48).

The original negative of this photograph is square, with more sky and more foreground: the print taken from this shows how that of 1882 was trimmed to secure a better composition, similar to that of 1869. Judging from the one surviving negative of Stillman's 1869 photograph, for that he had used the whole plate, without trimming.

Hellenic Society negative 3029.
Catalogue no. 9875.
16.70 x 11.00.

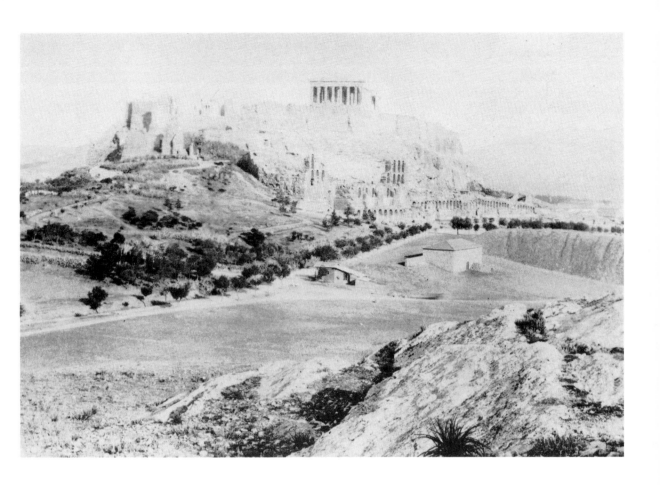

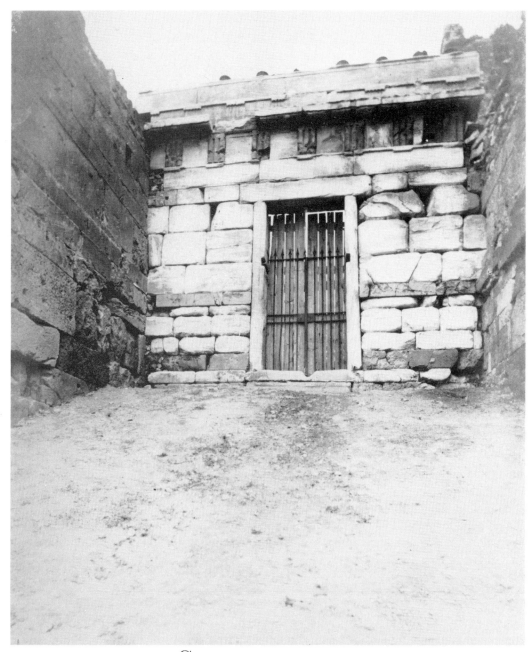

5. STILLMAN, 1869
Ancient Gate of the Acropolis

Catalogue no. 9783.
19.20 x 22.80.

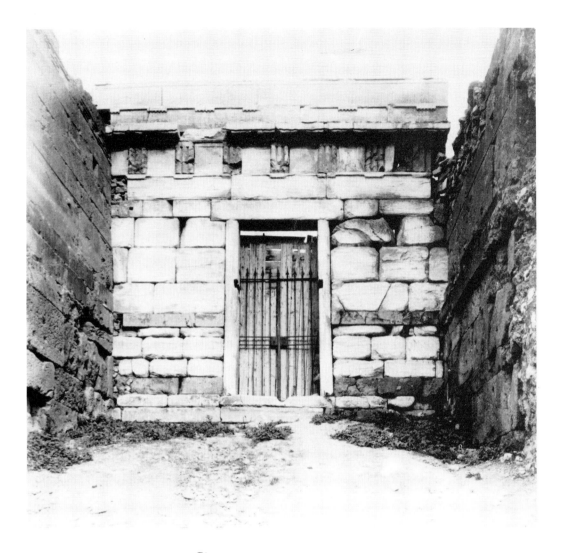

6. STILLMAN, 1882

The Beulé gate

Put together from classical fragments (note the second Doric architrave over the cornice) as part of the Late Roman fortifications, this gate was concealed by the end of the Turkish period, when it was completely incorporated into a gun bastion.

This is now the principal entrance to the Acropolis; for the ticket office door and windows, holes were put in the wall on the left of these photographs which show it in its original condition.

Catalogue no. 9782.
17.30 x 16.30.

7. STILLMAN, 1869

*The Western façade of the Propylaea with the Temple of Victory and
the ancient steps. At the extreme right is the Parthenon; at the left
the detached mass is the pedestal of the statue of Agrippa. The
square tower, which rises above the Temple of Victory, belongs to
the period of the Genoese Dukes of Athens.*

A view taken from the top of the Turkish fortification immediately to the south of the Beulé gate. Notice the shadow on the right of this and the next two photographs, cast by the high Turkish wall (and gateway entrance) which linked the Nike bastion with the Beulé gate, and itself appears in views of Nike, Plates 13 and 14. Stillman took a sequence of photographs when he had set up his apparatus on this part of the wall, and they can be distinguished by the position of the shadow cast by the Nike bastion (as pointed out to me by Gary Edwards). This is the version that was used in the album.

The details of the Frankish tower are particularly clear, and it is possible to make out, just to the left of the left-hand column of the reconstructed temple of Nike, the end of an architrave and architrave backer blocks of the façade of the south-west wing of the Propylaia. This had been incorporated, except for its outer *anta* (the decorated termination of the wall) and column, into the north wall of the tower: it was

the existence of these surviving parts of the Propylaia, which had to be made visible if its complex architecture were to be properly appreciated, which led to the proposals to demolish the medieval structure which concealed them.

The photograph gives a good view of the restoration (by Ludwig Ross) of the Nike temple, particularly of the plain drums of marble inserted into the columns where the original material was deficient. The narrow flight of steps by the side of the Nike bastion on the lines of the Roman stepped approach, which survives (together with the slabs of the central roadway) at the bottom of the ramp, was removed in the latest amelioration of the approach, carried out in the 1960s. At that time a zig-zagged path was installed on the false belief that this was the form used in Classical Greek times.

Plate 6 in *The Acropolis of Athens*.
Catalogue no. 9788.
24.30 x 18.40.

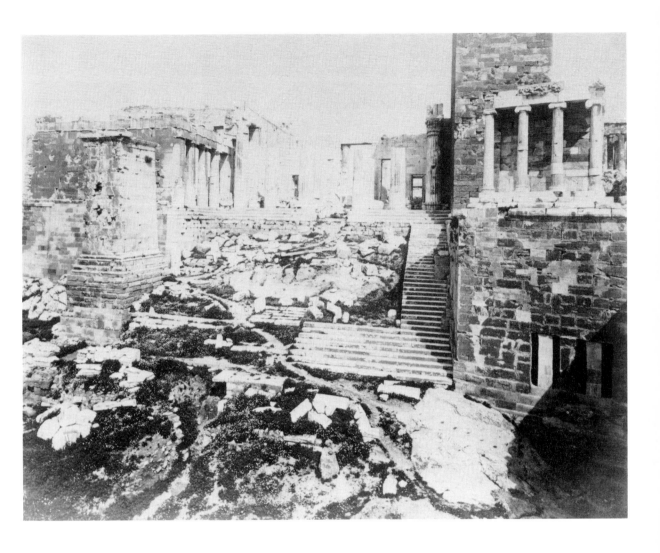

8. STILLMAN, 1869

Stillman has now moved his apparatus round from its position on the Serpentize where he took Plate 6 to the top of the Beulé gate, or, more precisely, the northern part of the gate structure, the modern ticket office. It is probably the same day – the sun has moved round, and there is now little shadow by the Nike bastion. In Stillman's album in the Gennadeion Library, Athens, this photograph is included (separately mounted) with No. 6: it does not have a separate caption, but is inscribed (on the negative) on the lower courses of the substructure supporting the Agrippa monument (part of which is visible at the right-hand side), 'Propylaea, from the gate', with Stillman's monogram and the year. It is also numbered 6A, in white, in the bottom left-hand corner, so was obviously intended to accompany No. 6 in the original series.

Note the door at the bottom of the Frankish tower, probably a Turkish insertion to give access to the gun bastion they constructed from the base of the Nike temple.

Plate 6A in *The Acropolis of Athens*.
Catalogue no. 9793.
24.20 x 19.00.

9. STILLMAN, 1882

The same general view as 7, but taken from over the centre of the Beulé gate (fig. 6, p. 11). The main difference is the demolition of the Frankish tower, from which the surviving section of the south-west façade has now emerged, though for its termination and *anta* support a section of the tower remains, with the same blocks still in their original position. These remained until the outer column and *anta* were restored by A.K. Orlandos in 1950.

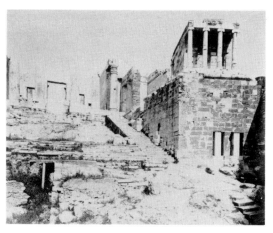

Hellenic Society negative 3019.
Catalogue no. 9789.
19.40 x 15.80.

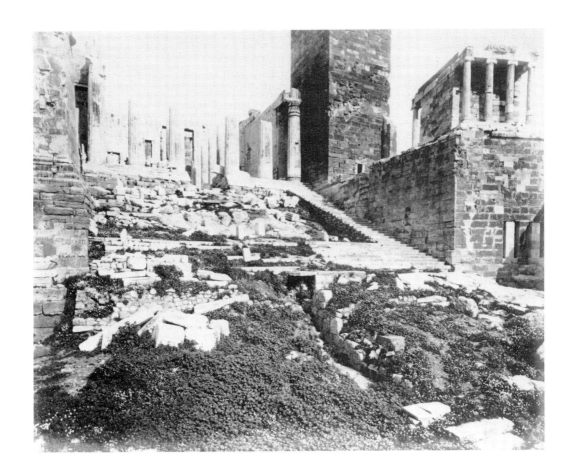

10. BEDFORD, 1862

Athènes, La Propylaea, du temple de la Victoire.

The general positions of the architectural fragments collected on the floor of the Propylaia and in the passageway are the same in this photograph, in Stillman's photographs of both 1869 (7) and 1882 (8) and, as far as they can be seen in the other photographs, Bonfils of 1870/1. This includes the small statue of Athena standing on an entablature block between the end column of the main gatehouse and the first column of the façade to the *pinakotheke*, the north wing (note also the head at the doorway to that wing).

This photograph was acquired by Sir Lawrence already mounted by Marion and Co., with the title of the series, 'Egypt, the Holy Land, Syria, Constantinople, Athens, etc.' The fact that Sir Lawrence entitled this in French suggests it was an early acquisition.

Catalogue no. 9792.
26.50 x 20.30.

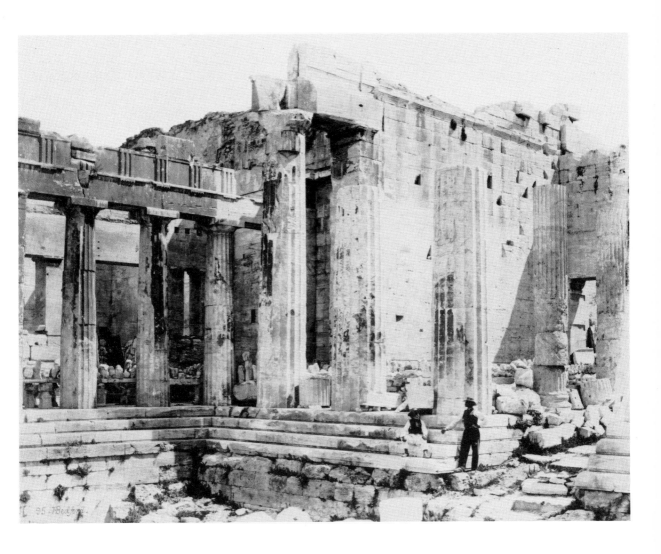

11. Probably STILLMAN, 1882

Athens Propylaea

Little, if any, change from the earlier state, though perhaps some of the fragments on the slab bench in the porch of the north-west wing have been removed to the Acropolis Museum, now complete (and an indication of the later date).

This photograph is mounted on the same card as the second series of Stillman's photographs, but there is neither print nor negative of it in the Library of the Hellenic Society, so its attribution to Stillman must be uncertain.

Catalogue no. 9787.
14.00 x 17.60.

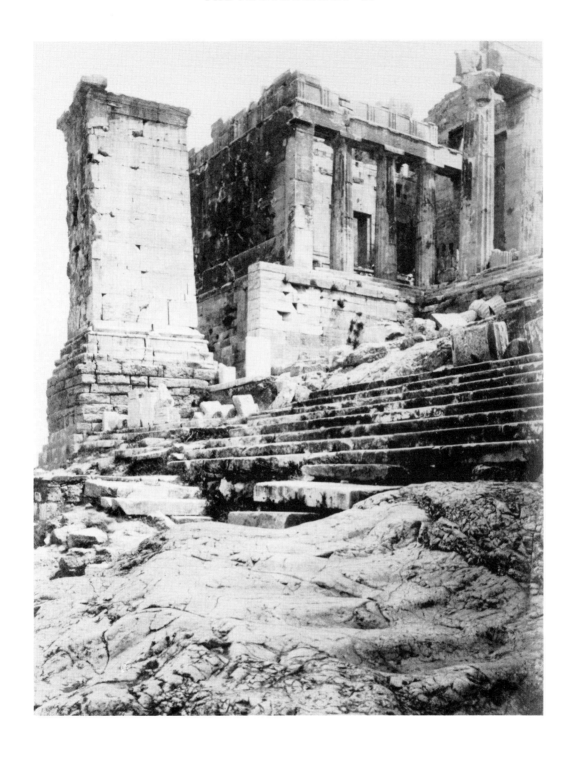

12. Possibly STILLMAN, 1869

Athens Temple of Victory

The Temple of Victory, re-erected by Ludwig Ross in 1836 after the demolition of the Turkish gun bastion in front of the Propylaea.

This corresponds to Stillman's Plate 7 (east façade of the Temple of Victory), and is mounted on the same blue-grey card as the 1869 Stillman photographs in the Alma Tadema Collection, but differs slightly from the version in the Avery Architectural and Fine Arts Library of Columbia University (a carbon print) and that in the cast gallery of the Ashmolean Museum, both of which have a figure standing by the south side of the temple, and Stillman's full signature on the piece of marble lying at an angle in the middle foreground. In the Stillman photograph, the gate into the *cella* of the temple is open. A small piece of stone on top of the block in the very front of the Stillman photograph is missing in our version. The weed growing in the crack between stylobate and middle step, at the junction of the first two blocks on the middle step, is larger in this photograph than in Stillman's. There are other weeds grow-ing on the steps, so it must have been taken at a different time. There appears to be a signature on the bottom left-hand block but this is not really legible. In all other respects it is very close to Stillman, but taken from a very slightly different angle: it must belong to the same general period, before the removal of the sculpture stored in it to the Acropolis Museum in the mid-1870s. Gary Edwards suggests (in a letter) that it may nevertheless be Stillman's work, and certainly one would expect Sir Lawrence to have acquired it along with the prints of the Stillman 1869 photographs. It is the same size as the other 1869 Stillman photographs. The gap in the centre of the steps has now been filled with new blocks of Pentelic marble carved to the original design. The gap was presumably made to gain access to the hollow interior of the temple's base, which would make a useful gun position after the demolition of the original superstructure.

Catalogue no. 9795.
18.40 x 23.60.

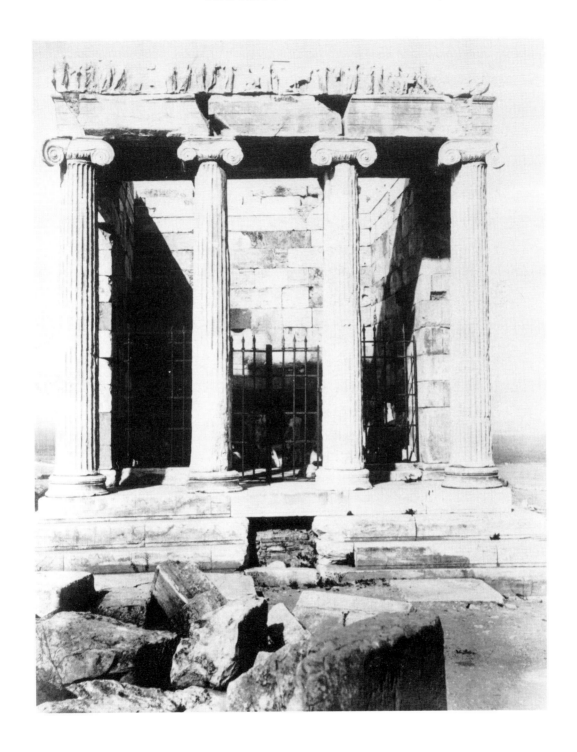

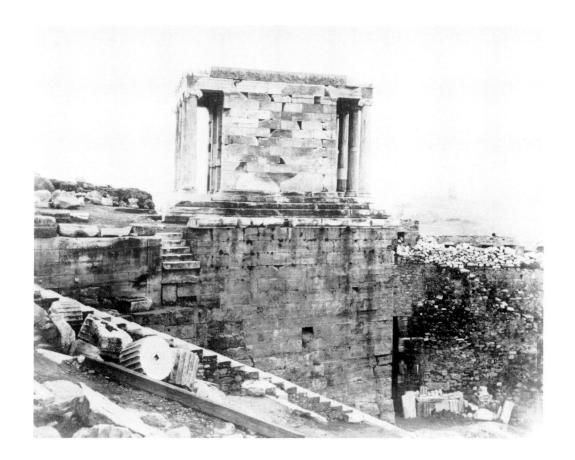

13. STILLMAN, 1869

Temple of Victory

The temple re-erected by L. Ross in 1836. Much of the Turkish walling, now demolished, still survives in this photograph – battlements on the Nike bastion, to the left of the temple (their continuation removed when the temple was re-erected on this former gun bastion); then the main wall beyond the bastion, with the side of the principal entrance gateway into this part of the defensive system (the Beulé gate being totally concealed in Turkish times.) The gun ports in the battlements survive, but the whole of the parapet walk is cluttered with building stone and architectural fragments.

Despite its absence from the Gennadeion Library copy of Stillman's album and the lack of signature and date, the fact that our print is marked in white as 7A, and is repeated by Stillman in 1882, demonstrates that this is by Stillman. It is also within the normal dimensions of Stillman's 1869 photographs.

The Turkish fortifications were finally removed in 1890.

Catalogue no. 9797.
24.00 x 19.20.

14. STILLMAN, 1882

The same view as Plate 13, with no significant changes, except that the fallen column drums from the Propylaia have been removed.

Hellenic Society negative 3022.
Catalogue no. 9796.
17.60 x 15.90.

15. BONFILS, 1877

Athens Temple of Victory

Unlike the majority of Bonfils' photographs in the Alma Tadema Collection, this does not have the characteristic signature and reference number scratched on the negative, but carries across the bottom, in white, and in a different handwriting, 'Bonfils Athènes Temple de la Victoire sans ailes/Grèce', with the reference number (681) underneath the name. It is not mounted on the same card as Sir Lawrence's early Bonfils photographs, suggesting it was acquired at a different time. So it is presumably one of the second series of Bonfils photographs. There is, of course, no significant change in the appearance of the temple. From the architectural point of view this is a more useful photograph than that shown here in Plate 12 (and Stillman's very similar Plate 7), since it shows the inner piers, concealed by the façade column in the strictly frontal view of Stillman. By the time this photograph was taken the sculpture, especially of the Nike parapet, which was previously stored in the temple, had been removed to the Acropolis Museum, thus confirming a date after 1875: compare the photographs of the sculpture by Sébah and Stillman, Catalogue nos. 9968 (Plate 82) and 9874 (Plate 81), taken when it was still in the temple.

Catalogue no. 9794.
22.20 x 27.80.

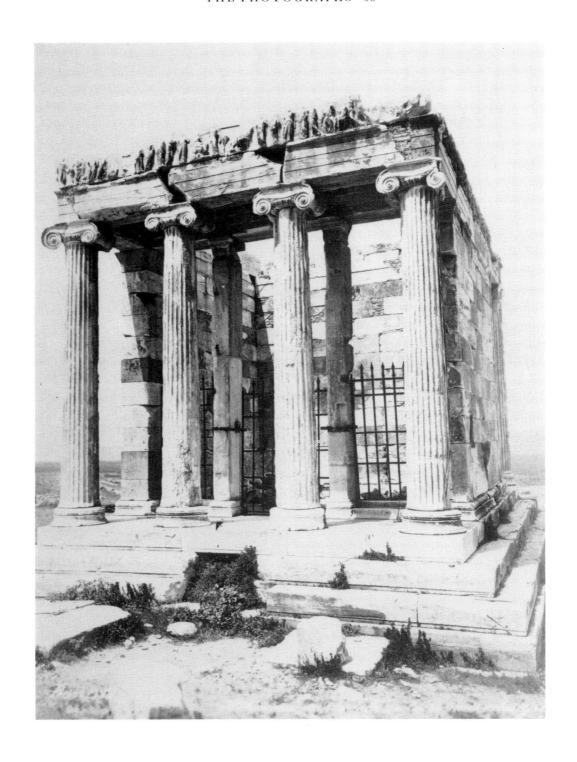

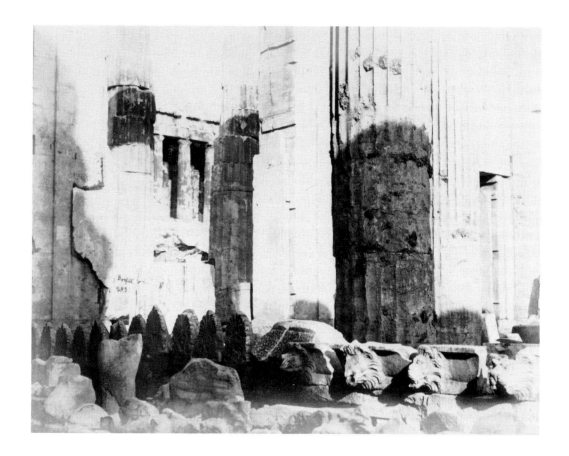

16. BONFILS, 1870/1

Athens, Propylaea

The cross-wall of the gate halls of the Propylaia, seen from the north side of the outer hall, looking into the Acropolis. The Parthenon in the background. Note the lumps of mortar still attached to the Ionic column in the foreground, and the surround slabs of the original doorways.

Signed by Bonfils on the negative, this is therefore one of the earlier series. Note the lions' head spouts from the gutter and the antefixes, part of the collection of architectural fragments belonging to the building and at this time collected together in it.

The effect of Bonfils' lens in this photograph is to bring the façade of the Parthenon too close to the Propylaia.

Bonfils 283.
Catalogue no. 9791.
28.00 x 21.30.

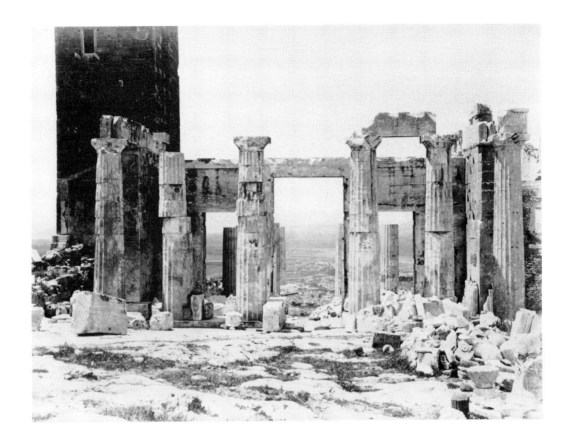

17. STILLMAN, 1869

The eastern façade of the Propylaea. The island and bay of Salamis
are seen through the central intercolumnization, and through those
at the left the port of Piraeus.

Details of the Frankish tower are clearly visible, particularly the two projecting beams under the opening high in the east side, to support a platform.

Unlike most of Stillman's 1869 photographs, this one has no signature or date on it. Stillman has now gone through the gateway into the Acropolis, and has turned his camera to get the reverse view, looking outwards. The view to the sea is quite clear, and extends over more or less continuous olive groves, where all is now concrete buildings (assuming the normal atmospheric pollution has lifted to make the same distant view possible).

Plate 8 in *The Acropolis of Athens.*
Catalogue no. 9790.
24.00 x 18.40.

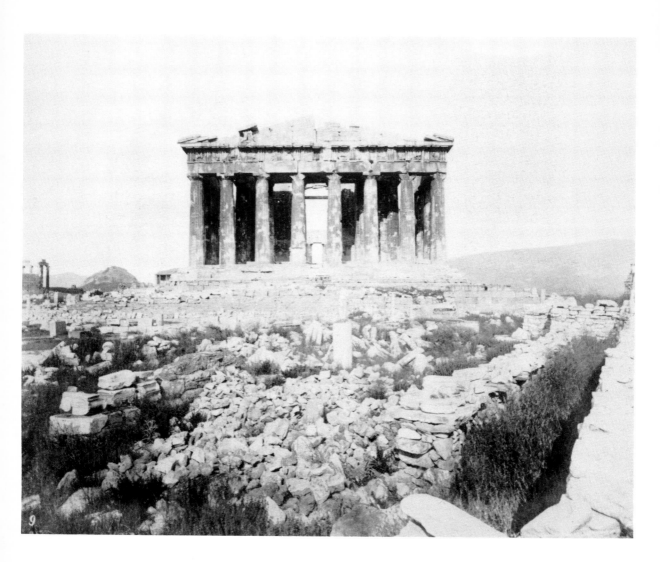

18. STILLMAN, 1869

Western façade of the Parthenon. At the right is Hymettus, at the left the summit of Lycabettus is seen and at the extreme left is the Erechtheum.

The precarious state of the west door of the Parthenon is clearly visible. The remaining stone beam at the top of the door opening (part of the late Roman doorway) is in fact some distance below the surviving stonework, and does little more than brace the sides. Several of the capitals of the Doric columns are badly damaged. The south side of the Erechtheion is partly restored. In the background, behind the Parthenon, lies one of the Turkish buildings, left to house sculpture and other fragments before the construction of the Acropolis Museum.

Stillman Plate 9.
Catalogue no. 9878.
24.00 x 19.01.

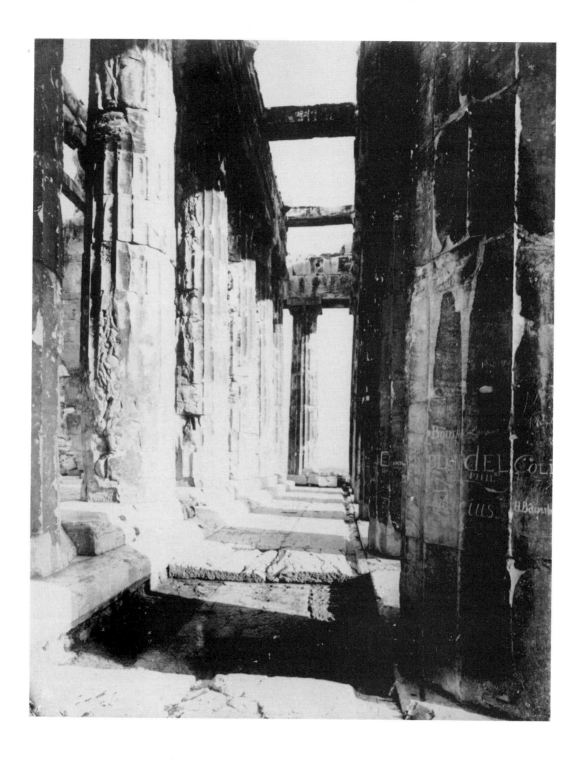

19. STILLMAN, 1869

Western portico of the Parthenon (Names on the columns are of the Philhellenes who fought here in the war of Greek Independence.)

View at the west end of the Parthenon, looking south. This plate gives the clearest view of the crumbling masonry above the west door, and the stone beam beneath it. The urge to inscribe one's name on the Parthenon long antedates the War of Independence, and (as some of the dates visible here show) some of the names were added after that war. But some, including M. Blondel who adds to his name 'Phil(helle)ne 1826' must have been those of the westerners who supported the Greeks during the war and, in particular, the siege of the Acropolis in 1827.

Plate 10 in *The Acropolis of Athens.*
Catalogue no. 9885.
19.20 x 24.10.

20. STILLMAN, 1882

The same view as Plate 19, though the door is more obscured by the columns. Some of the less deeply inscribed names on the columns have been obliterated: none of them now survive.

This picture is not among the Hellenic Society negatives, but a carbon print is in the Union College Schenectady album of Stillman photographs.

Catalogue no. 9886.
16.70 x 18.80.

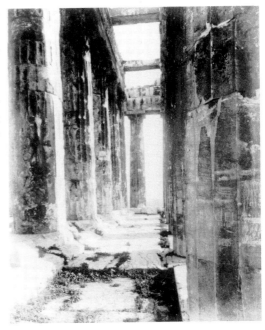

21. STILLMAN, 1869

*Interior of the Parthenon taken from the western gate. The circular
grooves are those in which the bronze valves swung.* (Stillman has
made a mistake: the doors of the Parthenon were
wooden.)

The interior of the Parthenon, with original floor slabs interrupted where the original cross-wall was removed when the building was converted into a church. The west end is in shadow; the east end, unfortunately, in sunshine, and so rather over-exposed, so that the details are not clear. It is just possible (perhaps with the eye of faith) to make out the surviving section of the apse built into the east end when the Parthenon became a church (see Plate 29). Clearly visible, at the left-hand edge of the photograph, is part of the mortared brickwork added in the 1840s to hold up the surviving fragment of the north wall of the temple; and placed against this, slabs from Panathenaic frieze (slab VI of the north frieze, showing four water carriers, can be clearly made out). For these slabs, photographed by P. Sébah while they were still here in the *cella*, see below, Plates 70–75.

A comparison of Catalogue nos. 9894 and 9896 shows that the slabs were removed from this position between 1869 or 1870, when Sébah photographed them, and 1882, when Stillman took his second sequence. These were, of course, moved into the new Acropolis Museum. One of the slabs was photographed by Stillman in 1869 for Plate 25 of his album: see below, Plate 69.

The Alma Tadema print is a variant, not from the same negative as Plate 11 of the album, which has the Fustanella-clad figure, who also appears in the album in Plates 7 and 21. In the album version the figure is seated on one of the large blocks of marble on the right-hand side, and is taken from a slightly different angle. The different exposure darkens the foreground considerably, but makes the columns of the east end much clearer, together with the mountain behind them.

Plate 11 in *The Acropolis of Athens.*
Catalogue no. 9893.
24.00 x 18.70.

22. STILLMAN, 1869

*Western portico of the Parthenon from above showing the frieze in
its original position, the only portion which remains so.*

To take the photograph, Stillman must have carried his heavy camera up the steps of the bell tower of the Christian conversion of the Parthenon (later, when it became a mosque, its minaret) set into the south end of the west porch, below the right-hand corner of this photograph. He would then have crossed over by one of the surviving ceiling beams, like that which runs across this photograph, on to the top of the outer entablature. This is a strikingly successful photograph, which illustrates perfectly the architectural details of this level of the temple.

Plate 12 in *The Acropolis of Athens*.
Catalogue no. 9890.
24.00 x 18.90.

23. STILLMAN, 1882

The retake, from virtually the same position and angle, of Plate 12 in the 1869 album. The lens of Stillman's camera seems to have a slightly different focal length to that used in 1869, and the composition of the photo- graph, with more emphasis on the frieze, is less successful.

Catalogue no. 9891.
18.20 x 15.70.

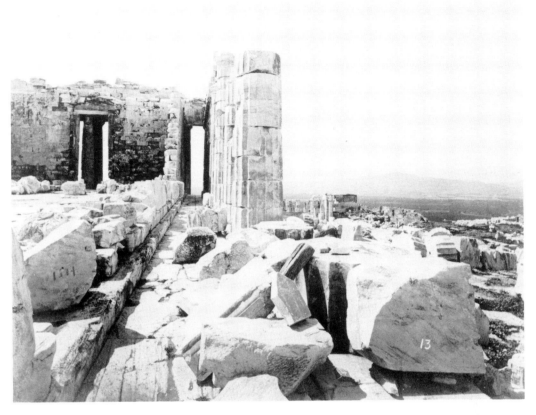

24. STILLMAN, 1869

Athens, Parthenon, Interior view looking east [sic]

This photograph was given the caption in Sir Lawrence's collection abbreviated from that of Plate 13 in the album, the 1869 version of Plate 25 in this book (a view taken from the same point as Plate 12 in *The Acropolis of Athens* and looking east over the ruins of the Parthenon). The photograph here is, of course, a view along the northern side of the Parthenon, looking west. Again, the perilous state of the west door is apparent. To the right of the columns, in the middle distance, are the remains of the Propylaia, and beyond, in the plain of Attica, a sea of olive trees where all is now concrete buildings.

This photograph is mounted on the blue-grey card and so was obtained by Sir Lawrence at the same time as the other 1869 photographs by Stillman. This one was not used by Stillman for the album.

Hellenic Society negative 3042, the only identified surviving negative of Stillman's 1869 photographs.
Catalogue no. 9888.
24.00 x 18.70.

25. STILLMAN, 1882

Athens, Parthenon. Interior from above looking east.

Not among the Hellenic Society negatives, but clearly a repeat of the 1869 version (Plate 13 in the album) taken from the same position as the 1882 repeat of the frieze, and at the same time.

The old palace (the present Parliament building) can be seen between the left-hand columns of the east façade, just under the architrave.

Catalogue no. 9892.
17.80 x 15.20

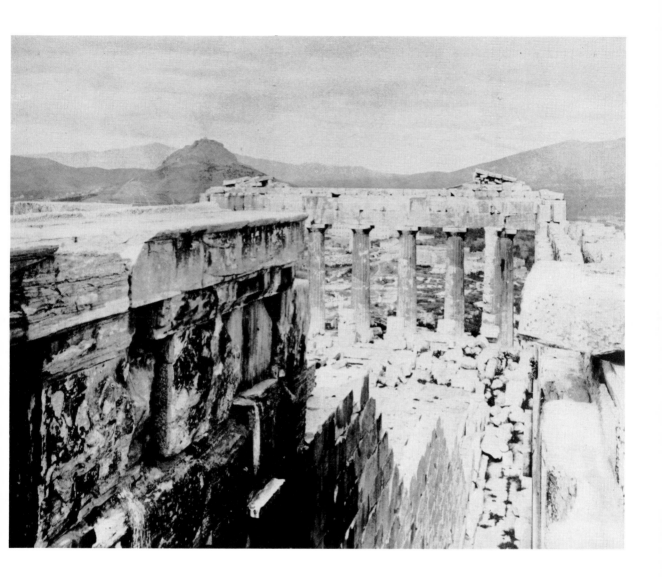

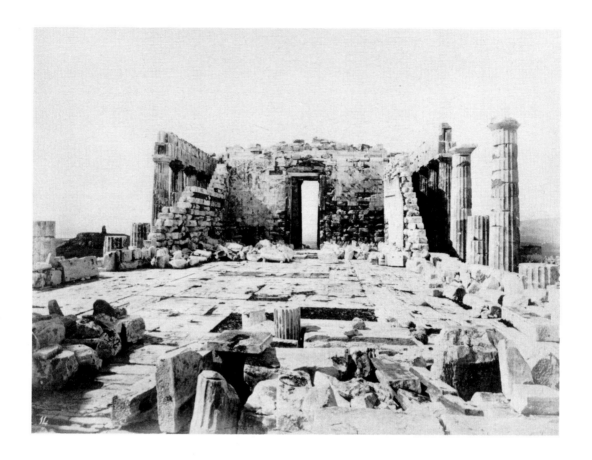

26. STILLMAN, 1869

Parthenon, interior looking west.

This seems to have been taken either from the block against which Stillman is seen leaning in Plate 28, or from the fragment of the apse. It gives a clear view of the west door in its unrepaired state; the mortared brickwork can be seen against the fragment of the north wall. The remains of the Christian paintings on the wall to the right of the door can be made out clearly: since the last century, these have faded very considerably.

Plate 14 in *The Acropolis of Athens*.
Catalogue no. 9894.
24.00 x 19.00.

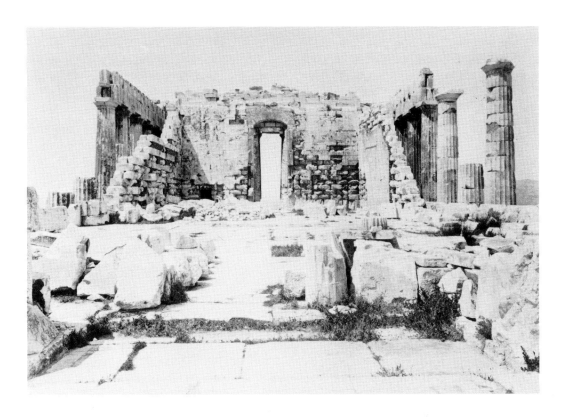

27. STILLMAN, 1882

Parthenon, looking west.

Essentially similar to Plate 26, but taken from the centre line of the building in the east porch, in front of the threshold of the east door, which is in the foreground. The repairs to the west door are clear in this photograph. These were carried out shortly after Stillman took his first series of photographs, and were complete by 1872; the lintel was reinforced with iron rods, and the brick and stone supporting arch inserted. A photograph of the Acropolis (now in the British Museum) shows this work completed, but with the Frankish tower still standing, prior to its demolition in 1875 (I am grateful to Ian Jenkins for showing me the album containing this photograph and allowing me to have a copy of it). The slabs from the frieze which were placed against the brick repairs to the north wall of the *cella* have now been removed to the Acropolis Museum.

Hellenic Society negative 3006.
Catalogue no. 9896.
18.90 x 12.50.

28. STILLMAN, 1869

*Eastern portico of the Parthenon, view looking northward and
showing Mt. Parnes in the* [extreme] *distance.*

Inscribed east colonnade in Stillman's writing on the top porch step, left foreground, but not signed. Parnes is barely visible in our albumen print: it is clearer in the carbon print version. The figure is presumably Stillman himself (the style of dress is not dissimilar to Russie's, in Plate 30), who either had time, given the long exposures required, to move from the camera to this position, or more likely if this was taken on the same day as Plate 30, Stillman allowed Russie to operate the camera (or possibly, the anonymous individual wearing Greek costume who appears on several of the photographs). There is a second version of this photograph, without the figure, which appears on Plate 15 in the Gennadeion Library copy of the album.

The columns on the left, of course, are the inner columns, in front of the east porch. It is clear from this photograph that the apse, still partly preserved at the time this photograph was taken, did not extend into the space between the porch columns and the columns of the façade on the right.

Plate 15 in *The Acropolis of Athens.*
Catalogue no. 9884.
18.80 x 24.30.

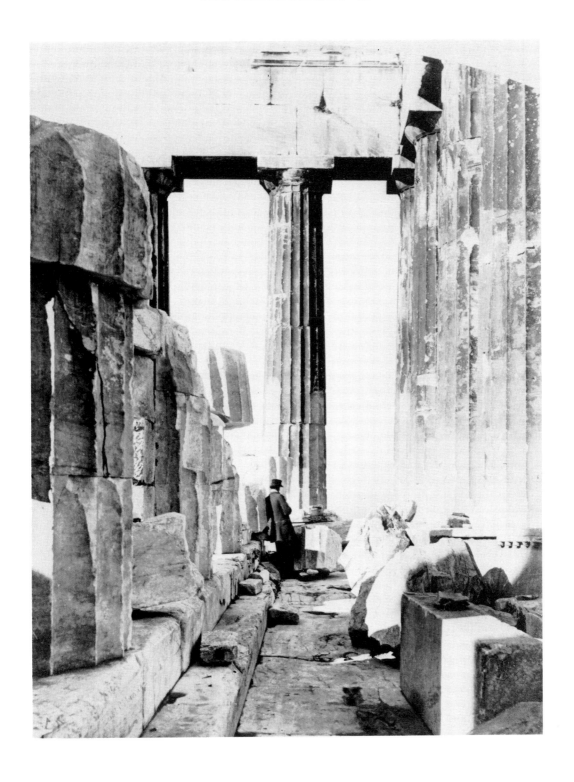

29. STILLMAN, 1869

Eastern facade, or front of the Parthenon.

Signed with Stillman's monogram, and the date, and description 'East Facade' on the fallen block in the right foreground. This differs slightly from the version in the Gennadeion Library, where it is Plate 16 and does not have the inscribed signature, though the print is trimmed to the same arched shape at the top.

This photograph shows clearly the remains of the apse constructed at the eastern end of the Parthenon when it was converted into a church. A good section, four courses in height, can be seen between the third and fourth columns from the right. The west door, seen between the central columns, is narrowed by the addition of slabs to either side. Above the doorway the original lintel block has gone and the succeeding stonework is in a very parlous state (the one thin lintel beam visible is not in fact directly under the main stonework – see Plate 19). There is a thin wooden beam over the eastern entablature, propping up the fragment of the pediment which survives on the left, already visible in Alfred Normand's photograph of 1851/2 and still there in Plate 25, of 1882. Part of the apse was removed in 1862 by C. Botticher, but Stillman's photograph shows that it was not then totally destroyed.

The other version was printed in the album because this negative appears slightly flawed by lettering, subsequently scratched out, on the stones in front of the second column from the right. These are the blocks in front of which Stillman's invalid son, Russie, is sitting in Plate 30.

Plate 16 in *The Acropolis of Athens.*
Catalogue no. 9877.
23.90 x 18.90.

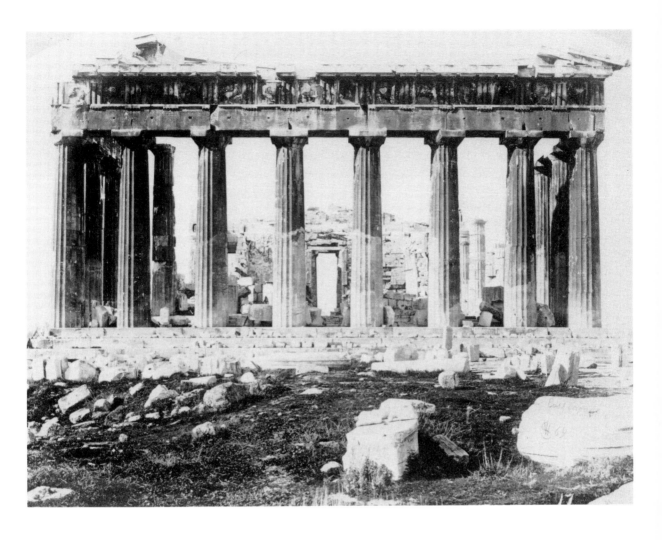

30. STILLMAN, 1869

Athens Parthenon Profile of the eastern front showing curvature of stylobate.

Signed and dated on the negative, central foreground, with description 'curve of stylobate'. The steps of the Parthenon are covered with fragments of sculpture and other pieces of marble, as in the previous plate.

There are two versions of this plate; one which shows Stillman's invalid son, John Ruskin Stillman (Russie), sitting by the large fallen block in front of the temple; and the other without him. The album in the Gennadeion Library has this version; that at Columbia University the version without Russie. The second version is also that in the collection of the Ashmolean Museum. In all these second versions the sculpture fragment (a small votive relief), which

in the picture shown here is lying face down at the end of the middle step to the north side, has been stood up. The composition of the second version is different: the camera has been moved to the left, and the print (which also has an arched top) is truncated above the architrave of the Parthenon, the effect being to show more clearly the front, and therefore the curvature of the bottom step. The block against which Russie is seated is more central and prominent – almost like a tombstone.

Plate 27 in *The Acropolis of Athens*.
Catalogue no. 9881.
18.80 x 24.00.

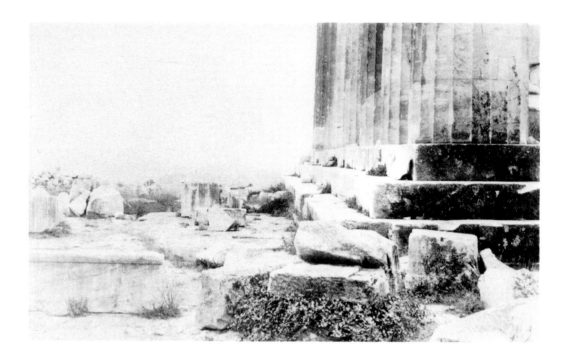

31. STILLMAN, 1882

Athens, Parthenon, profile of lower part of east front showing
curvature of stylobate.

Essentially the same view as Plate 30 (with the camera in the position of the second version of that plate). The fragments on the steps of the Parthenon have been removed to the museum, except the one at the end of the front middle step (Plate 32). The 'tombstone'-like block behind Russie has gone from this version, though the small broken stone on which he was resting an arm is still there. Stillman must have had the earlier version, and his now dead son, in mind, when he took the new photograph.

Hellenic Society negative 3008.
Catalogue no. 9882.
17.20 x 10.20

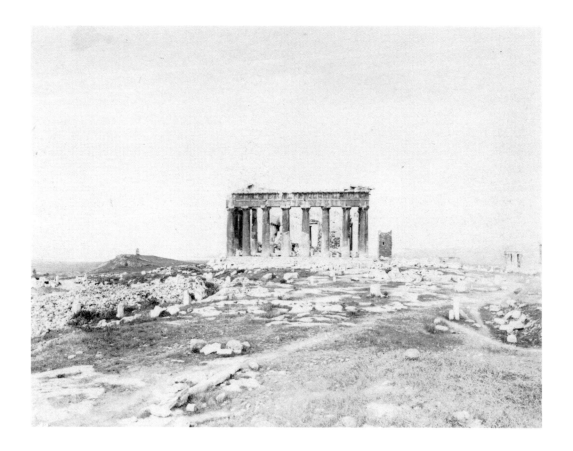

32. STILLMAN, 1869

View of the summit of the Acropolis from the extreme eastern point,
showing the Erechtheion on the right and in the distance, at the left
the Egean [sic].

A general view of the east front of the Parthenon. Also, clearly visible, the Frankish tower and the upper parts of the Propylaia and its medieval additions. To the left of the photograph, the hill of the museum and the monument of Philopappos. It is a view which shows the largely unexcavated state of the Acropolis in 1869, with enough earth cover, in places, to support vegetation, unlike the bare rock appearance of the present day. Unsigned.

Plate 18 in *The Acropolis of Athens.*
Catalogue no. 9876.
24.00 x 19.00.

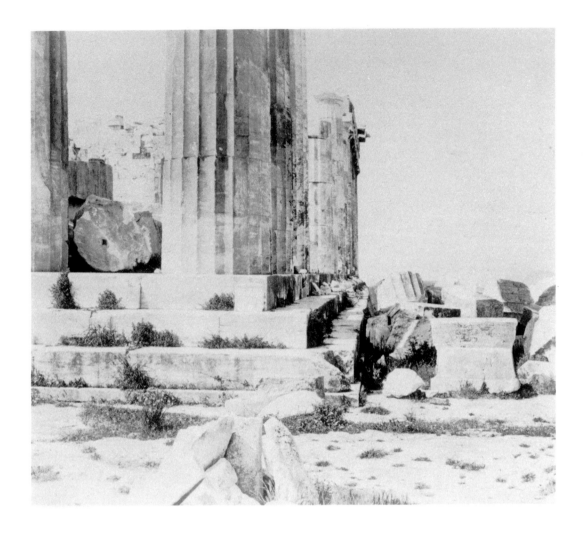

33. STILLMAN, 1882

Athens Parthenon profile of north side.

Some fragments of sculpture still on the steps of the north side, and one small relief of a seated figure at the corner. Not in the Hellenic Library negatives, but a carbon print of it is in the collection of Union College Library, Schenectady, which holds a complete album of the 1882 prints. From the state of the vegetation on the steps, it was not taken at the same time as Plate 31 but is part of the same series.

Catalogue no. 9883.
18.50 x 15.90.

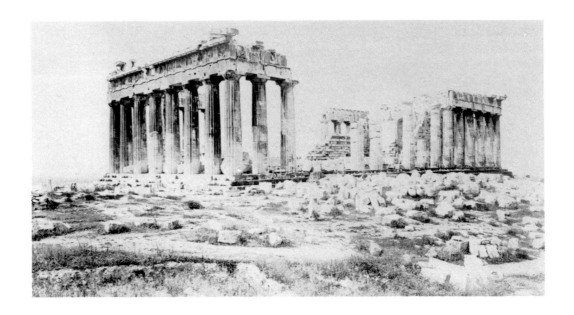

34. STILLMAN, 1882

Athens, Parthenon view from the N.E.

Note the scatter of column drums by the centre of the north side, lying where they fell when they were blown out by the explosion of 1687, and not yet restored into their original positions by Balanos.

Hellenic Society negative 3004.
Catalogue no. 9880.
19.20 x 9.70.

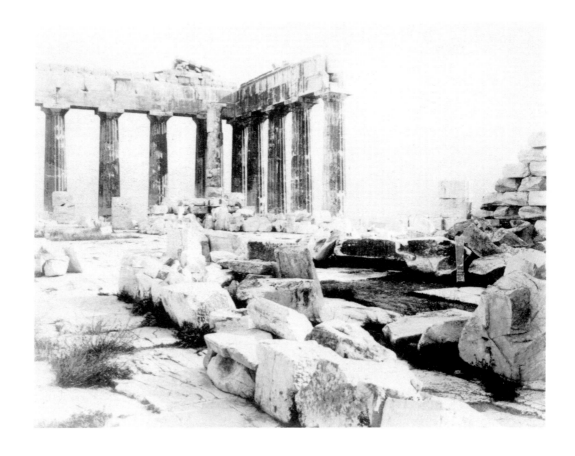

35. STILLMAN, 1882

Athens Parthenon interior looking south east.

The piece of timber behind the east pediment is still in place in this view, and the interior of the temple is still full of architectural fragments. These include a carved stone leg against the fallen blocks on the right-hand side which remained from the conversion of the Parthenon into a church, not having been considered important enough to be moved, with the sculpture, into the museum.

Hellenic Society negative 3005.
Catalogue no. 9895.
18.40 x 14.20.

36. STILLMAN, 1882

Athens Parthenon interior view.

The shape of the print matches that of the negative and shows the greater variability in the Stillman 1882 series. It shows the west doorway of the Parthenon with the post-Classical narrowing. This was added, probably after a fire damaged this part of the Parthenon, in the later Roman period. The arched repair to the lintel is now in position; all this was removed later by Balanos, to restore the doorway to its original proportions. The stone beam behind the arch, which appears in the 1869 photograph, rests on the post-Classical door-surround, and is part of it; here it can be seen that it has had to be reinforced with two iron bands.

The figure standing in this photograph cannot be recognized.

Hellenic Society negative 3012.
Catalogue no. 9887.
8.60 x 17.80.

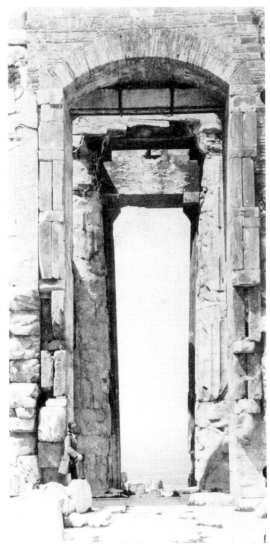

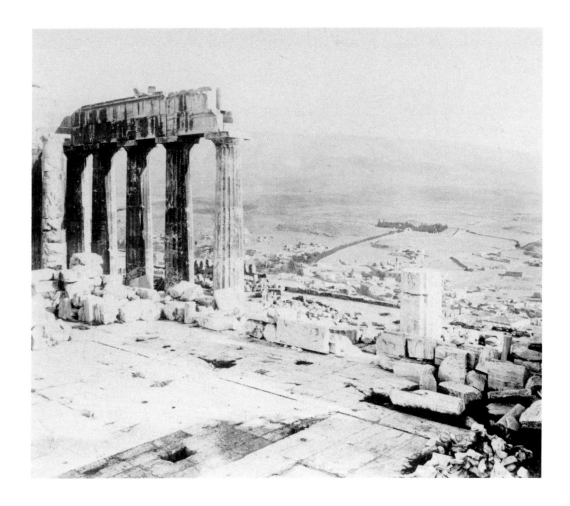

37. STILLMAN, 1882

Parthenon, interior view looking south east.

A view looking across the south side of the Parthenon. The avenue of trees in the middle distance leads up to the main cemetery, in 1882 in open country (now, of course, this area has been engulfed by the modern city). A few of the trees still survive to line the street to the cemetery gate. There is no copy of this print in the Hellenic Society Library: it is probably negative 3011, which is also missing.

Catalogue no. 9889.
19.00 x 15.90.

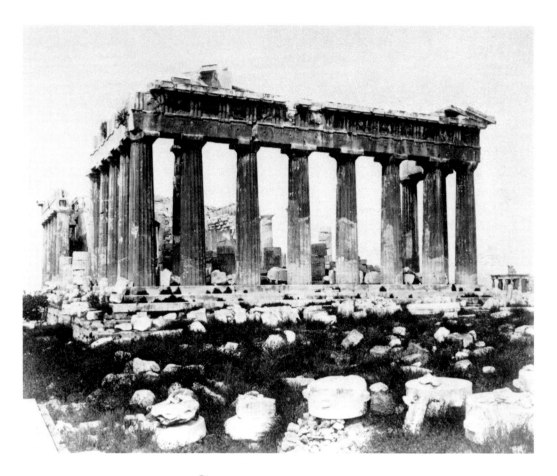

38. STILLMAN, 1882

Parthenon, view from S.E.

Though there is a negative of the 1882 series of Stillman photographs in the Hellenic Society Library showing a view of the east front similar to that in Plate 18 of 1869, there is no print of this in the Alma Tadema Collection. This view, from the south-east, is the nearest, but as there is no negative of it in the Hellenic Society, it is uncertain whether it is by Stillman. It must have been taken at the same time as Plate 34 in this book – the vegetation on the top step, now cleared of fragments of stone, is the same – which is definitely one of the 1882 Stillmans.

Note the unfinished, but damaged, drums from the earlier Parthenon in the foreground.

Catalogue no. 9879.
17.70 x 14.30.

39. STILLMAN, 1869

Erechtheum. [To left on the blue-grey mounting card; to the
right, in a different hand] *Eastern façade of the Erechtheum.*
The centre is the portico of Minerva Polias, at the left the tribune of
the Caryatids, and at the right the portico of the Pandrosium.

The view was taken from a greater
distance than the 1882 version no. 9840
(Plate 46) so that more of the Acropolis
is visible, in particular the Frankish
tower (and the upper parts of the Propy-
laia beside it). Otherwise there is no
significant archaeological change be-
tween the two photographs, and the
fallen blocks are in the same position in
both photographs, though naturally,
more are visible in this one.

Plate 19 in *The Acropolis of Athens.*
Catalogue no. 9841.
24.00 x 18.00.

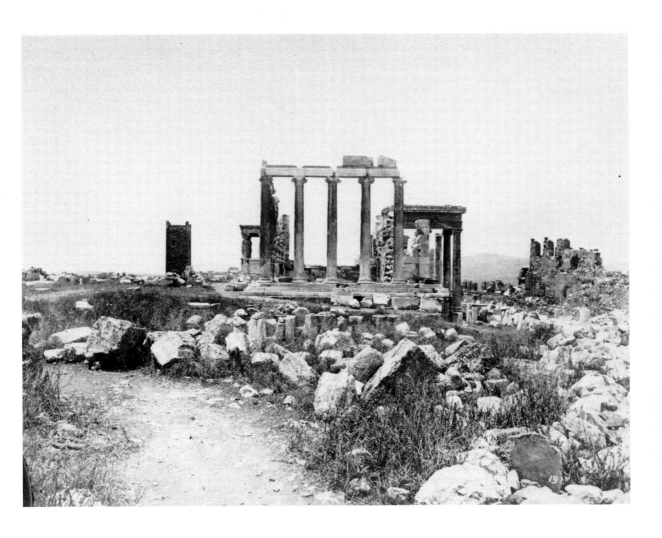

40. STILLMAN, 1869

[On blue-grey card] Left: *Athens Erechtheum, Portico of the Pandrosium*. Right: 41 *Portico of the Pandrosium (from the north)*.

Comparison with earlier views of the north porch shows the extent of the early repairs (and the damage inflicted on this porch in the siege of the Acropolis during the War of Independence.

In the pencil drawing by F. Arundel in the British Museum, 'View of the Temple of Erechtheus at Athens 1834' (London BM GR 1950 12. 13.1), the front of the porch is largely walled up with rough rubble. (Other eighteenth- (Stuart) and early nineteenth-century (Pars) watercolours and drawings show that then the porch was intact, though totally enclosed with this later walling, to form a room.) In 1834 only the two eastern columns of façade are complete, with architraves and other details, as in Stillman's photograph. The other two columns are partly standing, incorporated into the walling. Two ceiling beams are resting on the appropriate spaces on the back wall of the porch, but their front ends are on the lower level of the rubble wall. By Stillman's time these have been taken down, and can be seen in the foreground of Stillman's views. The block on top of the wall at an awkward angle has not moved. Up till 1869 restoration has been restricted, then, to the demolition of the later rubble walling requiring the two ceiling beams to be taken down. The upper part of column 3 has been re-erected, together with part of the corner column and parts of the column behind it, which has been reinforced with iron bands. (Visible in A. Normand's 1851 calotype, reproduced as Plate XX1 of Volume 80 of the *Bulletin de Correspondance Hellénique*, 1956.)

Plate 20 in *The Acropolis of Athens*.
Catalogue no. 9843.
19.00 x 23.80.

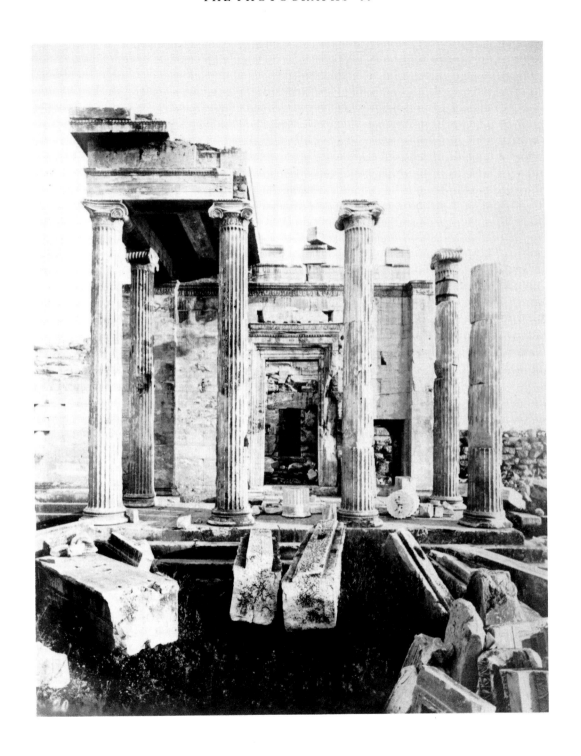

41. STILLMAN, 1869

[On blue-grey card] Left: *Athens Erechtheum Doorway of the Pandrosium*. Right: *Gate of the Pandrosium*.

The figure in Greek costume also appears on Stillman's photograph of the façade of the temple of Nike (which is not the version in the Alma Tadema Collection, Plate 11 in this book), and in the album version (but not our albumen print) of the interior of the Parthenon, looking east (Plate 21 in this edition). Placed by the side of the door, one against the other, are two coffer blocks fallen from the ceiling; in the foreground, an upside-down top column drum from one of the fallen porch columns, fully visible in the previous photograph.

Plate 21 in *The Acropolis of Athens*
Catalogue no. 9845.
19.00 x 24.20.

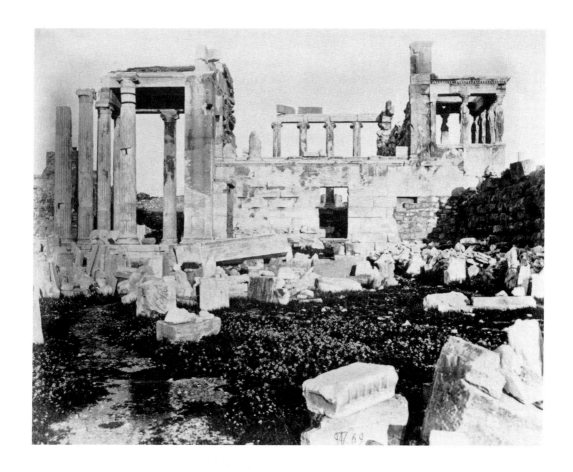

42. STILLMAN, 1869

[Signed with monogram 69. On blue-grey card] Left:
Athens Erechtheum. Right: *western flank of the Erechtheum.*

Photographed from the Pandrosion precinct. The gap under the southern end of the west wall (over the grave of Kodros) is filled with late mortared rubble walling. The remains of the late walling on top of the north porch are visible, as are the iron reinforcing bands on one of the columns of the north porch. Fallen blocks in the precinct include a marble beam from the north porch, a coffer block, and part of a seated statue.

Plate 22 in *The Acropolis of Athens.*
Catalogue no. 9842.
24.00 x 19.00.

43. STILLMAN, 1869

[On blue-grey card] Left: *Athens Erechtheum Tribune of the Caryatids*. Right: *Tribune of the Caryatids*. *(Fig. 8, p. 15)*

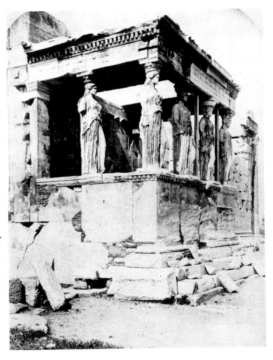

Note the brick patching, and the various sections restored rather crudely in marble, including the capital of the third caryatid from the left. The repairs can be seen clearly in A. Normand's calotype of 1851 (BCH 1956, 80, Plate XXII). The second from the left is of course a cast of the original taken by Elgin and now in the British Museum (Plate 50 below). These repairs are the work of A. Paccard, and were carried out in 1846–7. They have now been removed.

The Caryatids show the features of their faces clearly preserved, and should be contrasted with their present state, after they have been devastated by the acid rain of modern Athens.

Plate 23 in *The Acropolis of Athens*.
Catalogue no. 9846.
19.20 x 24.00.

44. BONFILS, 1870

[Signed in black on the print Bonfils 276] *Athens Tribune of the Caryatids*.

Mounted on the same blue-grey card as the Stillman 1869 plates, and so presumably acquired at about the same time, suggesting that all these photographs were bought not long after they were published.

Catalogue no. 9847.
27.50 x 21.50.

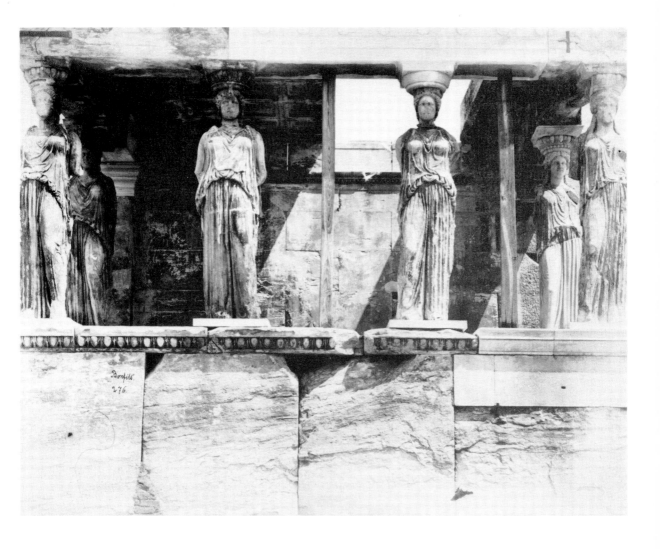

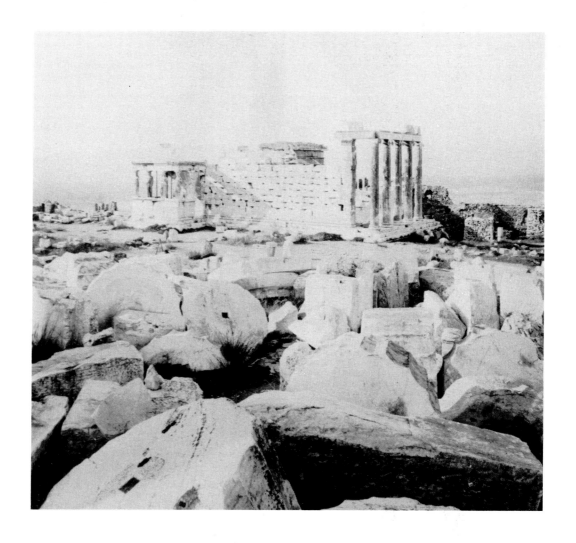

45. STILLMAN, 1882

Athens Erechtheum.

Photographed from the Parthenon, and with the fallen columns of the north flank of the Parthenon in the foreground. Note the Turkish walling at the top of the Acropolis perimeter wall, with fragments of the battlements. These walls are noticeable in the dis-

tant views of the Acropolis, such as Plate 4.

Hellenic Society negative no. 3013.
Catalogue no. 9839.
18.50 x 16.70.

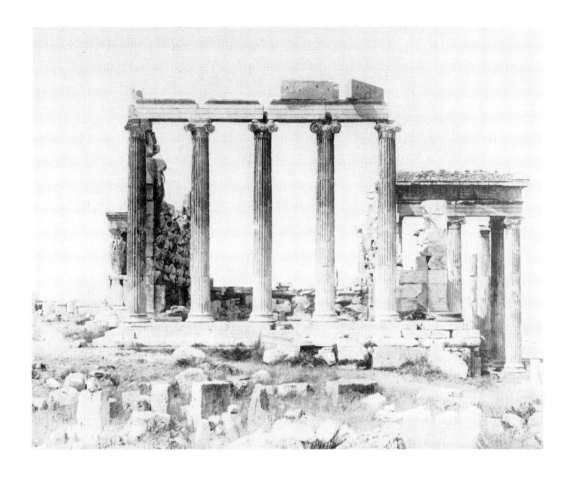

46. STILLMAN, 1882

Athens Erechtheum.

The east porch in the foreground. Like the previous picture (which is the same series), it is mounted on white card. The remains of mortared walling are still clearly visible on top of the cornice of the north porch.

Catalogue no. 9840.
18.30 x 14.20.

47. SEBAH

Ornament du Temple de l'Erechtheum [title only partly
visible] *Athens Erechtheum cornice* [sic.]

Showing a fallen fragment of the wall crown, the same block used by J. Travlos for Plate 291 of his *Dictionary of Ancient Athens*. (This is a print from a negative at the German Archaeological Institute in Athens, in which some deterioration in the crispness of the detail is noticeable.)

Sébah 130
Catalogue no. 9849.
34.00 x 26.00.

48. BONFILS, 1870

[Marked on the print 279 (in black), so one of the early
series, but mounted on white paper, rather than card]
Left: *Athens Erechtheum Fragments of cornice* [sic]. Right:
Fragments de Corniche du Temple Erechtheum [sic]. (Fig. 10,
p. 21)

The same fragment as Catalogue no.
9849, Plate 47. The block can be seen
here stood on end against some steps –
not the same setting as 9849, although
in that print the block is also stood on
end.

Bonfils 279.
Catalogue no. 9850.
29.00 x 23.00.

49. BONFILS, 1877

[Marked on the print in white, right-hand side of print, so
presumably 1877] *Athènes Portique occidental* [sic] *de
l'Erechtheum, Grèce.* [Mounted on grey card] *Athens
Erechtheum, west portico.*

It is, of course, the *north* porch.

Bonfils 518.
Catalogue no. 9844.
28.00 x 22.00

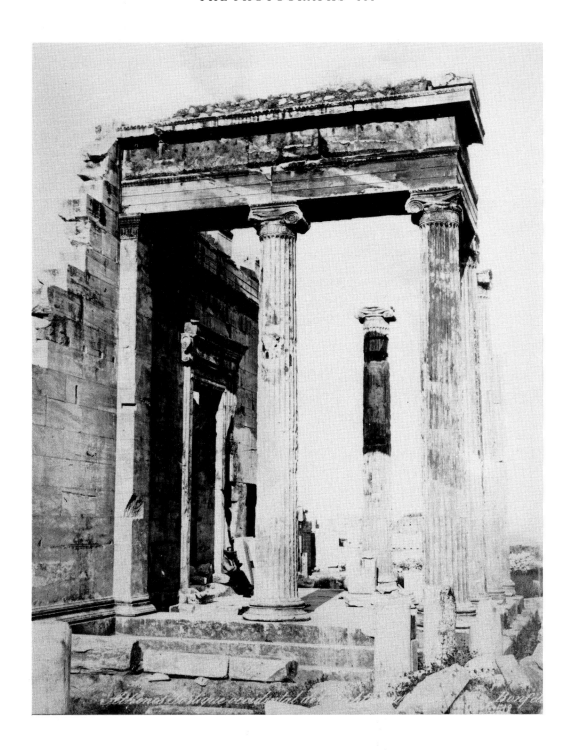

50. ANONYMOUS

Athens Erechtheum Caryatid

The green-grey card on which this is mounted differs from that of other photographs. XXXV is written at the top right. It shows an Athens Erechtheion caryatid, the example taken by Elgin and now in the British Museum.

This is a fine contrasty photograph. The caryatid stood in the Elgin room of the British Museum, against a wall, and with other material close to it. Here the whole background has been touched out on the negative, up to the outline of Caryatid, though in places not quite reaching it. Probably taken about 1870. (I am grateful to Ian Jenkins for discussing this photograph with me.)

Catalogue no. 9848.
19.00 x 28.20.

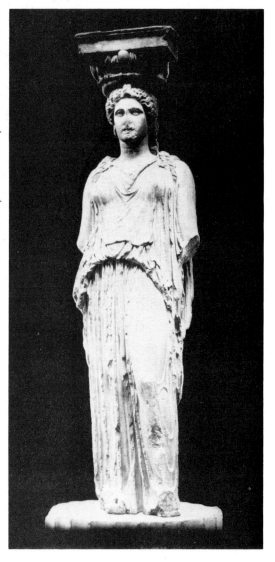

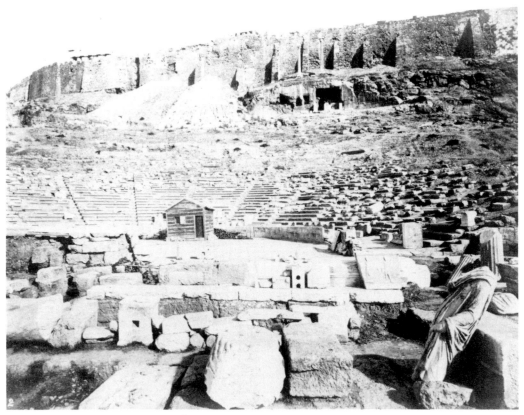

51. STILLMAN, 1869

The Acropolis with the Theatre of Bacchus [Dionysus]. *View taken from the proscenium of the theatre. The architrave of the Parthenon can be seen above the fortification wall.*

The theatre had been excavated in 1861–2, but some later work was carried out only a few years before this photograph was taken; the ramshackle hut obviously belongs to the excavators. This photograph gives a clear view of one of the tips, from the 1840s clearance of the Acropolis, which were allowed to spill down over the sides of the rock into the still uncleared upper part of the theatre. The statue in the foreground may have been deliberately placed there for effect: note also the relief slab standing behind it. The relief is probably Sybel 4993, and the statue may be Sybel 4994, but this is all very uncertain; by the time Sybel made his catalogue (1881) some of the sculpture found in the excavation of the theatre had been taken to the National Museum.

Plate 2 in *The Acropolis of Athens.*
Catalogue no. 9785.
24.30 x 19.00.

52. BONFILS, 1870/1

Theatre of Dionysus, Athens

This must be one of the earlier series of Bonfils, *Architecture Antique*, published in 1872: notice the piles of stones round the hut, which are identical to those in the photographs by Stillman (Plate 36) and J. Pascal Sébah (Plate 59). There is an almost identical view in Bonfils' later series *Souvenirs d'Orient* (of *c.* 1877 – copy in the J. Paul Getty Museum) but this has no pieces of stone along the side of the hut, and has a seated figure on one of the stone chairs behind it. Otherwise there is no change: the two upturned Ionic capitals at the gap in the wall round the orchestra (the central paved area) are still in place five years later.

Bonfils 298.
Catalogue no. 9800.
27.50 x 20.50.

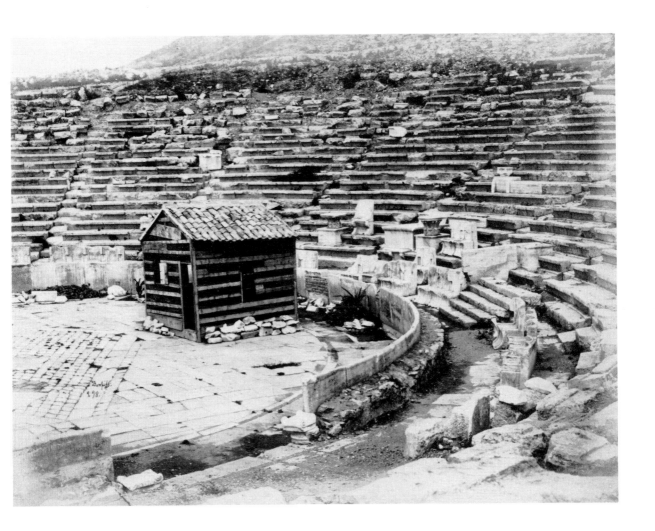

53. BONFILS, 1870/1

This is the view that appears in Bonfils' 1872 album, *Architecture Antique*. It gives a very clear impression of the ordinary seats, dating to the late fourth-century BC reconstruction of the theatre, and the later, Hellenistic stone thrones which were Sir Lawrence's principal interest here. The Alma Tadema Collection includes a drawing of one of these (fig. 3) and they were utilized in his painting 'Sappho'.

Note the Greeks with their traditional, distinctive, curving-ended shoes, also to be seen in Francis Bedford's photograph of the Propylaia (Plate 10).

Bonfils 297.
Catalogue no. 9799.
28.00 x 20.50.

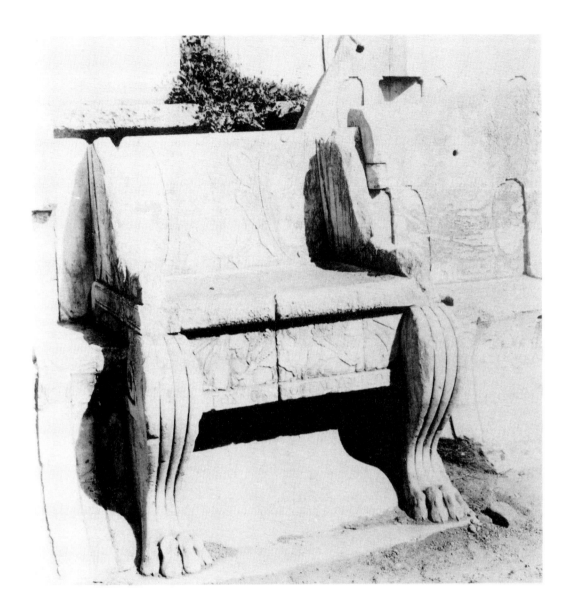

54. ANONYMOUS

Athens Theatre of Dionysus seat.

The throne of the priest of Dionysus of Eleutherae.

Catalogue no. 9806.
17.50 x 17.30.

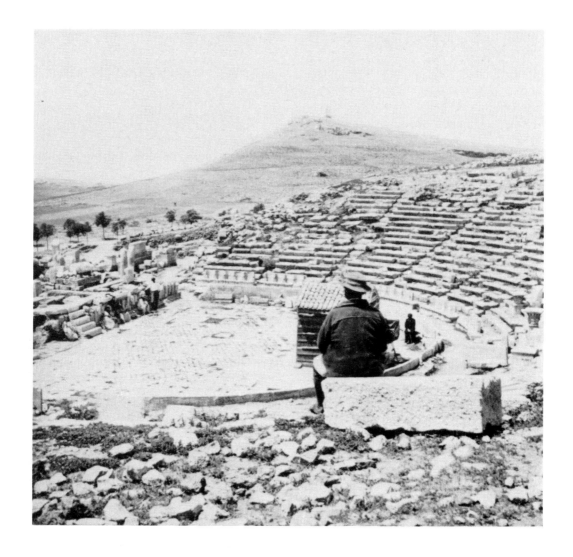

55. ANONYMOUS

Athens Theatre of Dionysus

One of three smaller photographs mounted together on a single blue-grey card: these were presumably acquired before the later series of Stillmans. Only one piece of stone is by the hut.

The whole photograph is rather out of focus, and unlike others in Athens there are several people in this view – a group of four by the façade of the Roman stage. This would appear to be a private

photograph of a party visiting Athens in the 1870s or early 1880s, rather than one of the commercial prints by a photographer such as Bonfils or Sébah. If this is the case, presumably the party comprised, if not Sir Lawrence himself, at least acquaintances. It would have been taken at the time the measured drawing of the stone seat was made.

Catalogue no. 9804.
8.20 x 7.60.

56. ANONYMOUS

Athens, Theatre of Dionysus, seats.

Mounted on the same card as Plate 55. A detail of the thrones and seats at the centre of the auditorium.

Catalogue no. 9803.
7.70 x 9.30.

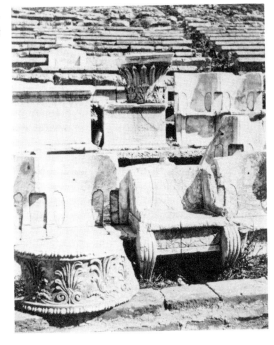

57. ANONYMOUS

Another seat, with an inscription of the
Roman period.

Catalogue no. 9805.
8.60 x 9.30.

Both these photographs suggest Sir
Lawrence's interest in details, especi-
ally of furniture, surviving from the
ancient world which could be used in
his paintings, and may well have been
made especially for him.

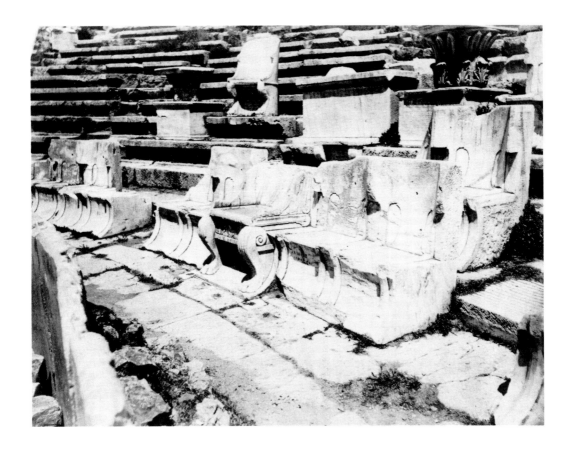

58. BONFILS, 1877

Athènes, detail interieur du Temple de Bacchus (Grèce)

In the 1877 album Bonfils refers to the 'Temple of Bacchus' in his caption to the repeat of Plate 52 (above). The same misnomer here suggests this is from the same general series, though it is not in fact part of the album: the 1872 Bonfils photograph is correctly labelled on its mounting card. Here is given a close-up of the Hellenistic stone thrones and chairs.

This is mounted on the same blue-grey card as the early Stillman series, and the earlier Bonfils photographs.

Bonfils 16 in white; 351 on the printed caption
Catalogue no. 9798.
28.00 x 22.00.

59. SEBAH, early 1870s

Athens Theatre of Dionysus. [In white, on the photograph]
Théâtre de Bacchus

View from the auditorium, looking south, over open fields, towards the solitary Roman column (in the dark field, left-hand side of the photograph) which now stands surrounded by blocks of flats and parked cars. It provides a good view of the remains of the stage building, as excavated.

It proved easy to identify the spot where Pascal Sébah set up his camera and to make a repeat of this photograph, which illustrates not only the way modern Athens has developed over the open fields of the photograph, but the way in which the remains of the theatre have not changed or deteriorated up to the present day (though now new consolidation work is in progress).

Sébah 63.
Catalogue no. 9807.
34.00 x 26.00.

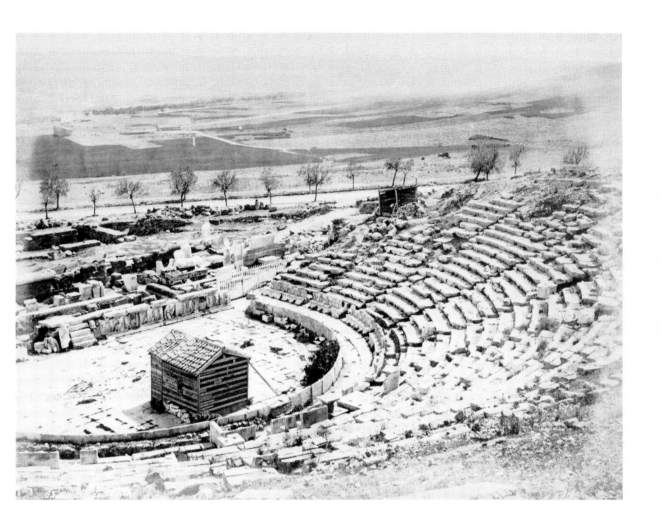

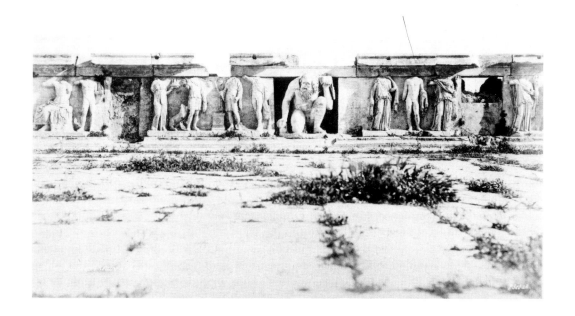

60. SEBAH, 1870s

Theatre of Dionysus, relief. [In white, on the photograph] *Bas relief du théâtre de Bacchus.*

The sculpture (cut down from its original form) that decorated the façade of the late Roman stage, the Bema of Phaedrus, originally of the time of Hadrian (early second century AD), and which still survives *in situ*.

Sébah 64.
Catalogue no. 9802.
34.00 x 26.00.

61. ANONYMOUS

Athens wall of Acropolis.

The wall in fact appears only at the top right-hand side of this photograph. Behind this is a section of the Acropolis rock, trimmed back at this point to accommodate the buildings in the foreground, the stoa of the Sanctuary of Asklepios – the *abaton* building in which patients who had come to the sanctuary to be healed passed the night, during which they would be visited by the god and cured. The arched opening leads to a spring, which provided the sacred water which was a fundamental element in the cult. The whole structure was

later converted into a Christian basili-
cal church, incorporating the earlier
building.

This was first excavated in 1876 (and
reported in Πρακτικάα (Transactions
of the Athens Archaeological Society)
in 1877) after the removal of the spoil
tips from the early clearances of the
Acropolis, visible in Plate 51 of 1869:
the buttresses of the Acropolis wall in
the top right of this photograph are
those behind and immediately to the
right of the tips in Plate 51.

This photograph is mounted on the
same card as the 1882 Stillmans and he
certainly utilized this second series of
photographs not only to repeat the view
of the 1869 series, but to record new
discoveries, such as the sculptured
gravestones of the Kerameikos. This is
possibly a Stillman, but there is no copy
or negative for it in the Hellenic Society
Library. It is not one of the two German
Institute photographs in J. Travlos' *Pic-
torial Dictionary,* though these must have
been taken about the same time.

Catalogue no. 9784.

19.30 x 16.20.

62. STILLMAN, 1882

Athens, Acropolis and Theseum

The attribution is uncertain. The Frankish tower on the Acropolis has disappeared, dating this photograph after 1875. All three steps of the *crepis* (base) of the building called the Theseum in the nineteenth century, but now known to be the temple of Hephaistos, are now visible, in contrast to the state of the building in Bonfils' photograph of 1870 (Plate 63) when the bottom step was still covered. The iron bands still hold together the broken drum of the corner column. The Areopagus is seen to the right of the Acropolis, and below the Acropolis the road which led from the Turkish town (i.e., the Plaka district) up to the Acropolis, more or less on the line of the ancient Sacred Way, and, behind it, part of the lower late fortifications round the Acropolis.

Catalogue no. 9777.
18.30 x 9.20.

63. BONFILS, 1870/1

Athens Theseum

The temple of Hephaistos on the Kolonnos Agoraios (the low hill above the western side of the agora). This was identified wrongly in the nineteenth century, on the strength of the subjects depicted in the carved metopes at the eastern end, as the shrine of Theseus, built by the Athenian statesman Kimon in the 470s BC when he brought back what he believed to be the bones of Theseus, the legendary founder of Athens, from the island of Skyros where he had died. The true Theseum was on the other side of the agora; and temples like this were dedicated only to gods, not heroes. The itinerary of the agora described in the second century AD by Pausanias makes clear that this is the temple dedicated jointly to the cult of Hephaistos, the craftsman god, and Athena. This part of Athens seems to have been the metal-workers' quarter: the temple is to celebrate their contri-bution to victory over the Persians by making the armour of the Athenian soldiers.

This view is taken from the south-west. The temple appears to have a two-stepped base: the bottom, third step has been concealed though it is visible in earlier painted views of the temple (it was a favourite for artists' views of Athens). The temple owes its good state of preservation to its conversion into a church, dedicated to St George; and thereafter as the burial place for English Protestants in the eighteenth century. It was outside the built-up area of eighteenth-century Athens. Note the iron bands holding together the fractured drum in the corner column.

Bonfils 373 (and his 1872 album).
Catalogue no. 9750.
27.50 x 20.20.

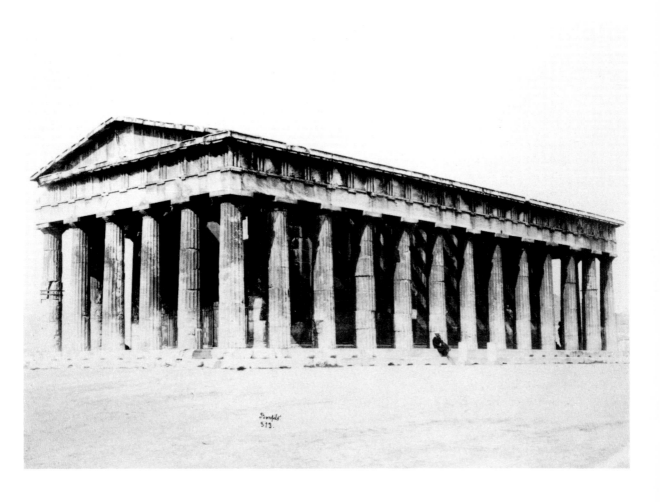

64. SEBAH, *c.* 1870

Athens Pnyx

The Pnyx was the hill next to the hill of the Muses and facing the west end of the Acropolis. It was the meeting place of the Athenian citizen assembly. The rock- cut stepped platform for speakers was made during the final reconstruction of the assembly place, 330–326 BC. The shepherd in traditional costume, and with his staff, was probably as much an affectation when Sébah took this photograph as it would be at the present day, though the photographs which show this area (such as Sébah's own photograph from the Theatre of Dionysus, Plate 59) do indicate clearly that in the 1870s this was all still open country.

Sébah 84.
Catalogue no. 9807.
34.00 x 26.00.

65. BONFILS, 1870/1

Athens Horologion of Andronikos Cyrrhestes (The Tower of the Winds)

A famous monument and landmark, the octagonal tower was originally surmounted by a weather-vane which pointed to the appropriate representation of the wind carved in relief at the top of the wall-section. This view is taken from the east, with Apeliotes, the East Wind, shown on the central panel; to the left is the South-East Wind (Euros), to the right the North East (Kaikias). On the left-hand section of wall the curved line marks the position of the water reservoir for the water-clock *(horologion)* which gave the tower its correct name. The original building was a gift to the people of Athens made by Andronikos of Cyrrha, in Asia Minor, in the first century BC. In Turkish times it was part of the *tekke* of the dervishes, who performed their ritual dancing or whirling in it. The plaster turban surmounting the roof was removed by Balanos.

Bonfils 317, for the 1872 album.

Catalogue no. 9808.

19.20 x 25.70.

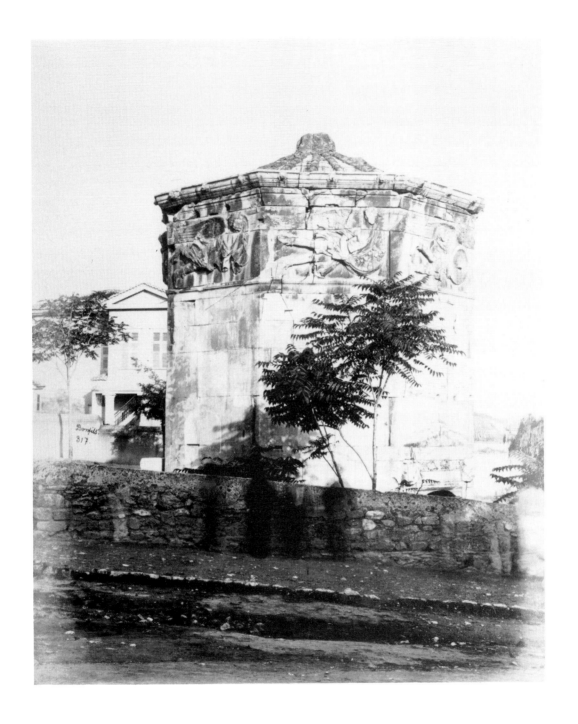

66. BONFILS, 1870/1

[On blue-grey card] Left: *Athens Temple of the Olympian Zeus.*

The east end of the temple, with the mortared masonry of the hermit's hut visible above the inner columns and ceiling beam.

This temple, both the view from it towards the Acropolis, and the view of it from the Acropolis, was a favourite with eighteenth- and early nineteenth-century artists.

Bonfils' photograph gives a detailed view of the columns, and also, just visible, part of the hermit's hut (also visible in Stillman's general view from Ardettos towards the Acropolis, Plate 1 above) which Georges Daux rightly surmised was the inspiration of Renan, in his celebrated passage '*J'aime mieux être le derrier dans ta maison que le premier ailleurs. Oui, je m'attacherai au stylobate de ton temple . . ., je me ferai stylite sur tes colonnes, ma cellule sera sur ton architrave.*' Renan visited Athens in 1865. Georges Daux wondered if the hermit's hut of the Olympieion still existed then. Bonfils' (and Stillman's) photographs show that it did.

Note that the left-hand figure has not posed for long enough to appear fully in the photograph.

Bonfils 310.
Catalogue no. 11980.
21.20 x 28.00.

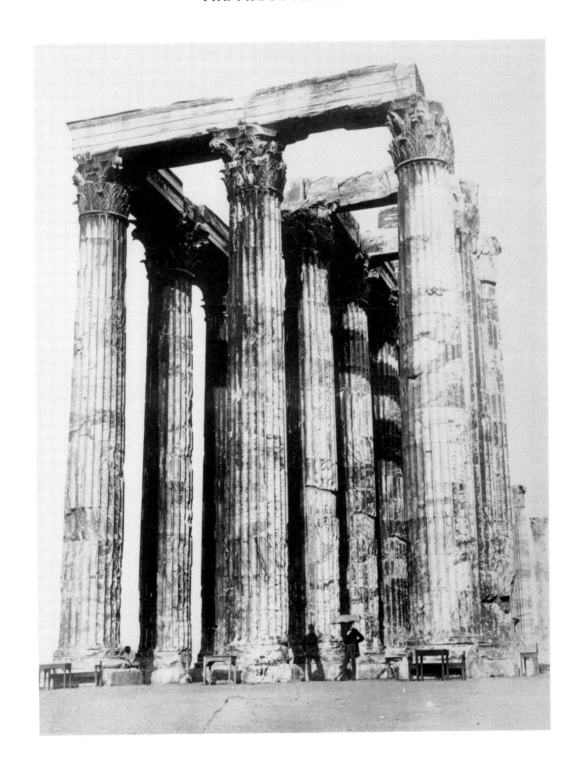

67. SEBAH

Monument de Filoppapos [sic].

[On green-grey card] Left: *Monument of Philopappos, Athens.*

C. Julius Antiochus Philopappos was a prince of the royal family of Commagene (now in eastern Turkey) who was exiled to Athens and became an Athenian citizen. As a benefactor of the city, the Athenians honoured him after his death with this monument, built between AD 114 and 116. His sarcophagus was in the building behind this monumental façade.

Sébah 83.

Catalogue no. 12183.

26.00 x 34.00.

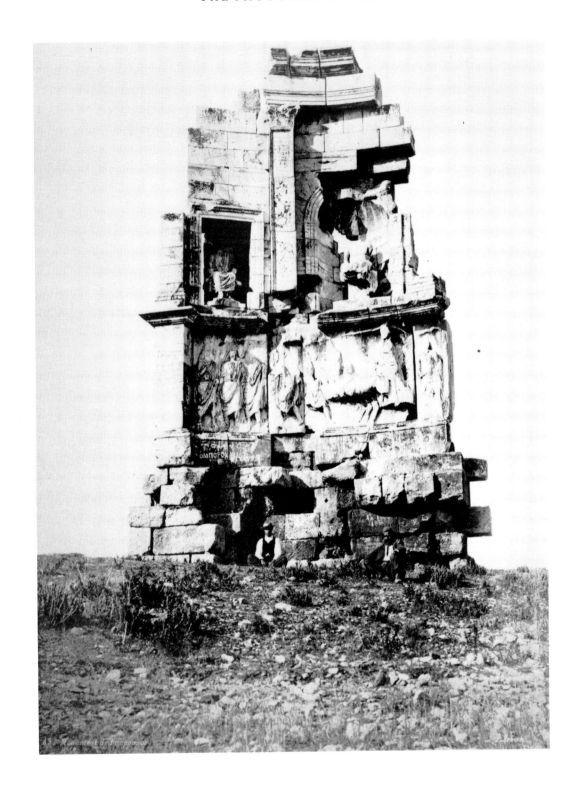

THE PHOTOGRAPHS OF SCULPTURE

Alma Tadema collected photographs of Greek sculpture to serve as models for the figures in his paintings, for their clothes and, to a lesser extent, their furniture (though he also collected pictures of Greek vases for these purposes).

Not surprisingly the collection includes a complete set of photographs of the Elgin Marbles in the British Museum which he was already copying in 1864, probably before he began to acquire the photographs. He relied on the sets of photographs generally available from commercial photographers at the time, that is, for the Elgin Marbles, the Mansell Catalogue. A selection of these have been included here which are of interest in showing how the Elgin sculpture from the Parthenon was displayed at the British Museum at that time, apparently in the early 1870s, when the Keeper, Sir Charles Newton, had returned the sculptures to the Elgin room: this is the place where they were displayed until transferred to the new Duveen Galleries. More important is the manner of display. Here is the original sculpture, together with casts collected assiduously since Elgin of all the relevant pieces of sculpture which were not in London, the purpose being to give as full an impression of the original monuments as possible (this was all swept away by the purism of the 1930s formulated by Bernard Ashmole and Sir John Beazley, who argued that only the original, fifth-century carving should be on view).

Other photographs of sculpture are even more interesting. They include the important photographs by J. Pascal Sébah and W.J. Stillman of those slabs from the Parthenon frieze which had been discovered in the clearing away of the Turkish buildings and other debris on the Acropolis after the establishment of Greek independence. One of these photographs, by Stillman, dates to 1869, the others, by Sébah, to a year or so later. At that time the Museum of the Acropolis was under construction, having been proposed in 1863. (Work started on it in 1865.) But it was still not complete, and the various sculptures found during the cleaning work were still displayed in the ancient buildings, where they had been deposited. The frieze slabs were simply placed in the *cella* of the Parthenon, against the mortared brick wall which had been added to strengthen the fragile surviving structure of original marble, along the north side, along with architectural and other fragments (some of the slabs, and these other fragments, can be seen in Plate 21, Catalogue no. 9893, a photograph by Stillman of 1869). It is not clear

whether Alma Tadema ever saw these slabs himself, since the photographs of them were originally labelled in ink 'BM' (though this was subsequently erased), giving the impression that he thought they were part of the Elgin Marbles. There is also Stillman's photograph of a metope, S12 (that is, the twelfth on the south side) of the Parthenon, kept along with the frieze reliefs in the *cella*.

Alma Tadema also looked for other examples of Greek sculpture. Here, in particular, can be seen evidence of him collecting pictures of the most recent discoveries. These come from two major excavations conducted in Athens in the 1860s, in the Kerameikos, the main cemetery area of the classical city, and in the theatre of Dionysus. For these he relied on J. Pascal Sébah. One of Sébah's photographs shows a sculptured grave monument (Plate 84, Catalogue no. 9832, the stele of Polyxena) with the breaks and gaps restored in plaster and placed, with another stele partly visible to the left, in the newly built National Museum, which had been started in 1866 and brought partly into use in 1873. This is NM 723. Another (Plate 87, Catalogue no. 9833, the stele of Archestrate) was photographed 'in the Theseum', then used as a depository for sculpture.

Others were still standing in the Kerameikos, and are simply labelled '*bas-relief (tombeau)*'. This includes the stele of Hegeso (Plate 86, Catalogue no. 9829), and that of Demetra and Pamphile (Plate 85, Catalogue no. 9831), also photographed by Stillman about this time. These were protected by temporary wooden framing, which can be seen clearly in the photograph of the stele of Demetra and Pamphile.

Alma Tadema also secured photographs of the more florid style reliefs executed at the end of the fifth century BC to decorate the balustrade which surrounded the temple of Nike, which were then kept in the temple itself. One is a 1869 photograph by Stillman, the other one of the series by J. Pascal Sébah. These slabs were discovered in the late 1830s during the demolition of the Turkish gun bastion which also revealed the surviving architectural members of the temple itself. Alma Tadema made several Greek pictures including dancers in movement or in exhaustion at the end of the dance. It seems to have been a favourite theme, and the highly detailed drapery of the Victory figures from the balustrade must have attracted him as useful models. Perhaps even more so was an actual representation of a dancing figure, on a slab found in 1862 in the excavation of the Theatre of Dionysus, re-used as a drain cover. This is another of Sébah's photographs (No. 102, *Bas-relief trouvé au Théâtre de Bacchus*, Plate 83), made while it was still in the theatre, some eight years or so only after its discovery. It is now thought to date to the first century BC, and reflects a classicizing taste which exactly parallels that of the patrons of Sir Lawrence Alma Tadema's art.

The remaining photographs of Greek sculpture are perhaps more surprising. Two photographs (Plates 88 and 89) were acquired of sculpture in the Musée Nani, part of a large series to judge from the numbers on them (102 and 117). The latter is the upper part of an Athenian grave stele, a woman holding a nude statuette of Aphrodite, a child (or servant) holding a duck: it is not of the same quality as the

Athens examples in the collection, nor as good as others in the British Museum itself which are not in the collection. The other (Plate 88), is a curious little votive relief, crudely carved and badly preserved, the dedication of Philokrates, son of Nikeratos, to the Nymphs. It does not show clearly either dress or attributes, though there is something in its composition – the three nymphs in front of a seated male – that recalls Sir Lawrence's own pictures. But it is difficult to see why these two, and the second in particular, were added to the collection.

In this section, references are given to recent, standard publications which discuss the sculpture for which Sir Lawrence collected photographs. These are all lavishly illustrated, and it is interesting to compare the various pieces of sculpture, as they were when Sir Lawrence's photographs were taken, with how they appear today. In some of them, it is clear that the sculpture has suffered damage (as well as the removal of the plaster cast additions at the British Museum) and in one case (Plate 71) part of the slab is now lost: this photograph gives a clear record of it, a fact apparently unknown to recent scholars who have studied this sculpture, and to whom reference is given.

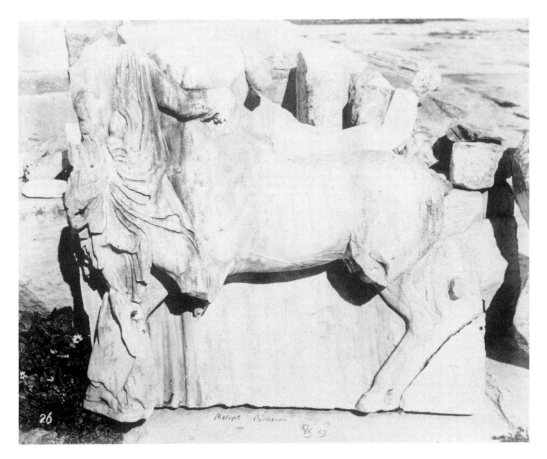

68. STILLMAN, 1869

Athens Parthenon Metope from South Frieze

Labelled on the photograph 'Metope Parthenon' with Stillman's monogram and the date '69', and with the white number 26 in the left-hand bottom corner. The copy of Stillman's book in the Gennadeion has only twenty-five entries, not twenty-six, and this photograph is not included. Nevertheless, Stillman repeated this photograph in 1882 (Hellenic Society negative 3040) by which time the metope had been moved into the museum. In this photo-graph it is standing in the Parthenon itself, with the other architectural frag-ments and reliefs from the frieze.

This is metope S12 (compare Franz Brommer, *Die Metopen*, Mainz 1967 *Taf.* 201, p. 9). Found in spring 1833 at the west end of the south side. Brommer does not seem to know of Stillman's plate, and it is not listed as one of the earlier reproductions of it.

Catalogue no. 9910.

24.00 x 18.90.

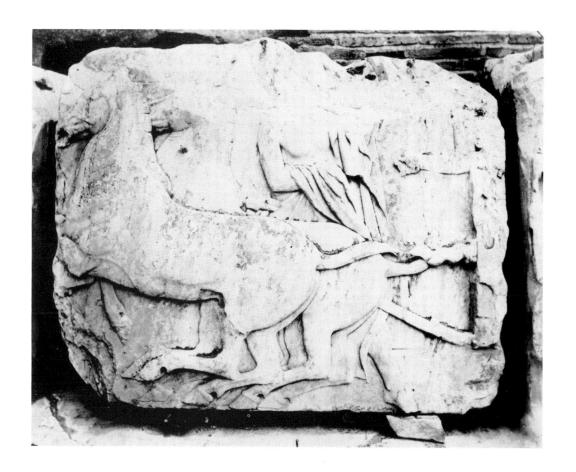

69. STILLMAN, 1869

[On blue-grey card] Left: *Athens Parthenon part of N. frieze
BM* [sic] Right: *north XIX M Frise.*

Despite the handwritten label, this is, of course, another of the slabs placed against the repair to the north wall of the Parthenon, not one of the Elgin marbles in the British Museum. It shows the north frieze, slab XIX, figures 62 and 63. Now in the Acropolis Museum. F. Brommer, *Der Parthenon Fries*, Mainz, 1977 (hereafter 'Brommer, *Fries*') p. 42 refers to Stillman, *Taf 25 bis.*

Plate 25 in *The Acropolis of Athens.*
Catalogue no. 9954.
24.50 x 19.00.

70. SEBAH

Frise deposé dans la cella du Parthenon [on print]. *Athens Parthenon Part of Eastern Frieze BM* [erased]. Right: *East VI m* [on grey card.]

A section of the east frieze, that next to the one shown in Catalogue no. 9920 (Plate 78), with Poseidon (36) Apollo (39) and Artemis (40).

Now in the Acropolis Museum, in *c.* 1870 this was one of the slabs kept in the Parthenon itself. Behind it can be seen the mortared brickwork added in the 1840s to support the surviving fragment of the north wall of the *cella*, and visible in several of the photographs which show the interior of the *cella*. The gap across Artemis' midriff where the stone was broken has now been filled, as have other minor gaps (compare the photograph, Plate 38, on p. 146 of M. Andronikos, M. Chatzidakis and V. Karageorgis, *The Greek Museums*, Athens, 1975, Brommer, *Fries, Taf* 178 p. 117 and Casson's *Catalogue of the Acropolis Museum II*, p. 105.) Found in 1836 under the east end of the Parthenon.

M. Collignon, *Histoire de la sculpture grecque*, II 59, fig. 26, has a similar plate taken when the sculpture was still in the Parthenon, but it is not Sébah's; and similarly of Catalogue no. 9949 (fig. 30, p. 65, Plate 73) and Catalogue no. 9950 (fig. 31, p. 66, Plate 74).

Collignon (*op. cit*, p. 53) also has a drawing of the west frieze '*D'après une photographie de Stillman*,' i.e., the photograph of the frieze *in situ*; probably the 1882 version (Plate 23 in this book) rather than that of 1869.

Sébah 93.
Catalogue no. 9923.
34.00 x 26.00.

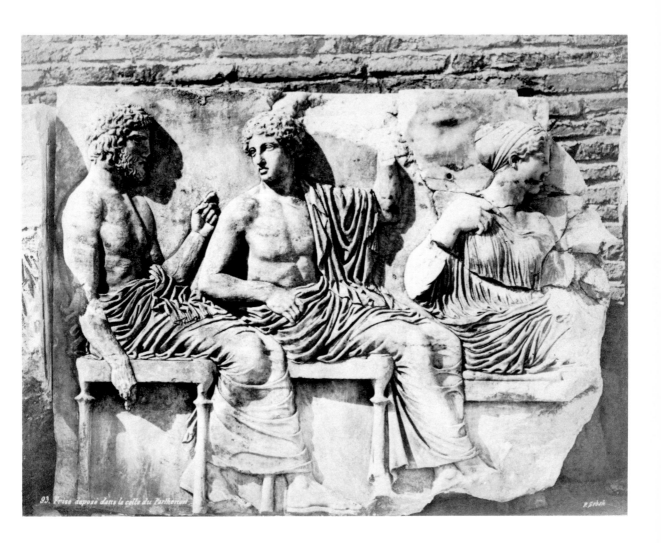

93. Frise déposé dans la cella du Parthenon

P. Sebah

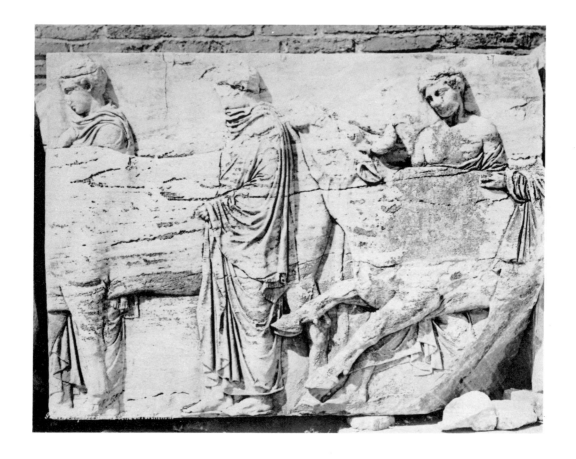

71. SEBAH

Frise deposé dans la cella du Parthenon [on grey card].
Left: *Athens Parthenon Part of N frieze.* Right: north II m
North frieze slab 11, figures, 3, 4 and 5.

The corresponding section on the north frieze to Plate 80 (Catalogue no. 9942, in the British Museum, on the south). In 1870, it was placed against the brick reinforcement of the north wall of the cella. In this photograph the bottom left-hand corner is intact and shows the complete folds of the drapery of figure 3. This corner is missing today, and the lines of the drapery break off. Found in 1833 'beneath its original position' i.e., having fallen directly from the building itself. (See also Casson II, 106, and Brommer, *Fries, Taf* 52.)

Sébah 92.
Catalogue no. 9945.
34.00 x 26.00.

72. SEBAH

Frise depose [sic] *dans la cella du Parthenon* [on grey card].
Left: *Athens Parthenon part of N. frieze;* right: *North IVm.*

Slab IV of the north frieze with figures 9, 10, 11 and 12. See *Fries*, Brommer and *Taf.* 55 p. 27 Casson II, p. 109.

Sébah 97.
Catalogue no. 9946.
34.00 x 26.00.

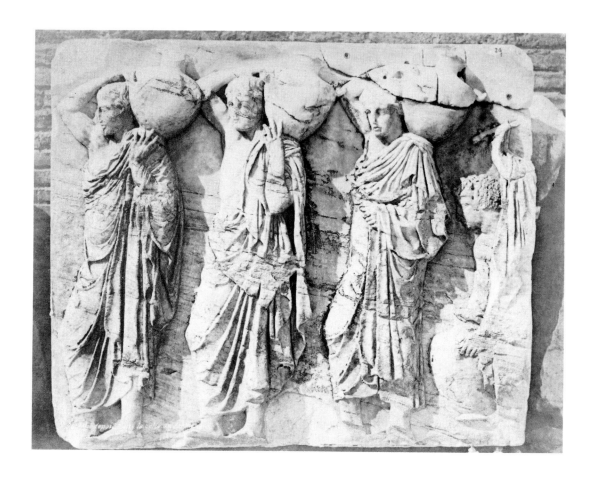

73. SEBAH

Frise deposé dans la cella du Parthenon [on grey card].
Left: *Athens Parthenon part of N. frieze [BM erased].*
Right: *north VI m.*

The watercarriers of the north frieze, figures 16, 17, 18, 19 of slab VI. Again, there appears to be more preserved of the bottom left-hand corner than now survives (*cf.* M. Andronikos *et al., op. cit.* (Plate 39) p. 147); Brommer, *Fries, Taf* 58, p. 29.

Also found in 1833 inside the peristyle of the Parthenon: Casson II, p. 112.

Sébah 94.

Catalogue no. 9949.

34.00 x 26.00.

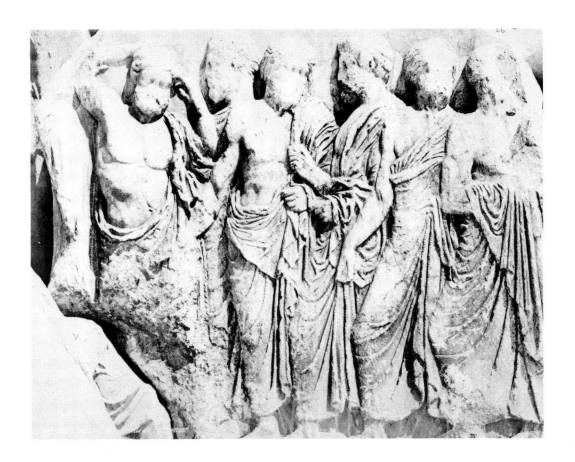

74. SEBAH

Frise deposé dans la cella du Parthenon [on grey card].
Left: *Athens Parthenon part of N. Frieze* [BM erased].
Right: *north X m.*

The separate fragment in the bottom left-hand corner – which is part of the main slab (*cf.* Brommer, *Fries, Taf* 64, p. 145) – is partly obscured by another block of stone in front. North frieze, slab X, figures 39, 40, 41, 42, 43. Found in 1835 at the north-west angle of the Parthenon (*cf.* Casson 113); Brommer, *Fries*, p. 33, *Taf* 64.

Sébah 96.
Catalogue no. 9950.
34.00 x 26.00.

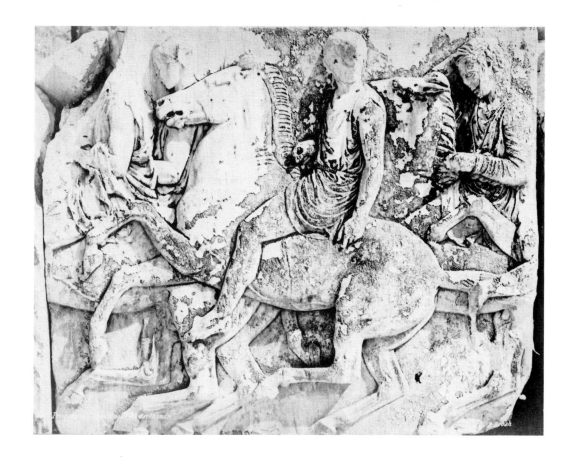

75. SEBAH

Frise deposé dans la Cella du Parthenon [on grey card].
Left: *Athens Parthenon Part of N. frieze* [BM erased].
Right: *north XXXI m.*

This stands in front of other pieces of stone rather than the brick repair. North frieze slab XXXI figures 94, 95, 96, 97. Brommer, *Fries*, p. 51 *Taf* 91; Casson p. 111. Brommer gives a reference to 'Stillman Taf 35' in the Gennadeion, presumably a misprint for 25, since Plate 69 (above) is referred to as 'Stillman Taf 25 *bis*'.

Sébah 95.
Catalogue no. 9960.
34.00 x 26.00.

76. ANONYMOUS (Mansell Collection)

[On white card] Left: *Athens Parthenon BM*. Right: *Eastern
pediment figures JKLMNO.*

General view of the Elgin Marbles.
The east pediment is in the foreground,
the frieze behind, the metopes set
into the wall. The photograph was taken
in the early 1870s, after Sir Charles
Newton had returned the Elgin Marbles
to the original Elgin Room, but before the
frieze (which is a *cast*) was covered in
glass to protect it (information from Ian
Jenkins).

Catalogue no. 9901.
27.60 x 16.80.

77. ANONYMOUS (Mansell Collection)

[Mounted on white card] *Athens, Parthenon angle of frieze from BM.*

East frieze, slab 1, figure 1, with beginning of (slab II) figure 4 next to it. A good, dark, contrasty print.

Catalogue no. 9851.

20.30 x 23.50.

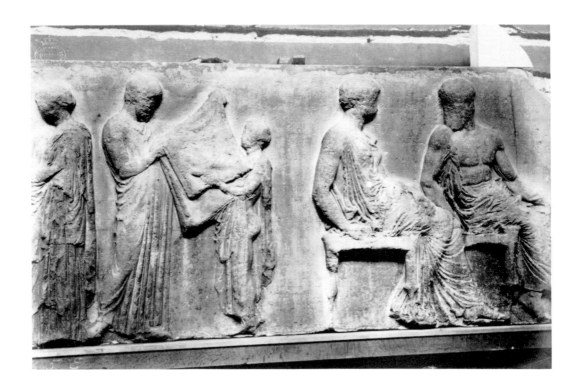

78. ANONYMOUS (Mansell Collection)

[Mounted on white card, raised slightly at edges – i.e., bought ready-mounted] Athens Parthenon BM *[written in pencil; added (stuck on) at bottom left of mount, printed caption from Mansell's catalogue:* 'Pentelic marble. Centre part of Eastern frieze of Parthenon representing the culminating part of the great Panathenaic Procession: the gods, Hermes, Poseidon, Demeter, Hephaistos, Hebe. About BC 440 Athens' *(between 440 and Athens* 'East V' *in ink).]*

In fact figures 33, 34 and 35 (the 'Peplos incident' where the special dress which has been woven for the traditional wooden statue of Athena is handed over) and, of the gods, only 36 and 37, Athena and Hephaistos. Note the evidence of alterations in progress on the wall of the Elgin Room behind this slab.

Catalogue no. 9920.
28.00 x 18.00.

79. ANONYMOUS (Mansell Collection)

[On white card, embossed at edge as 9920] *Athens Parthenon BM.* [Printed caption stuck on at right, out of the Mansell catalogue 680: *'BC 440 Pentelic marble. Part of southern frieze at Parthenon; officers of priesthood conducting to sacrifice cattle sent by the Colonies with their deputations to take prt in the great Panathenaic festival. About BC 440 Athens ('m XL' added in ink below 'BC 440' column).]*

South frieze slab XL, figures 112, 113, 114. The slab seen by John Keats, the 'heifer lowing at the skies' of his 'Ode to a Grecian Urn'. The background shows a distinct section of unplastered brick wall, as well as the plaster above, of the British Museum, indicating that alteration was in progress.

Catalogue no. 9942.

28.50 x 23.00.

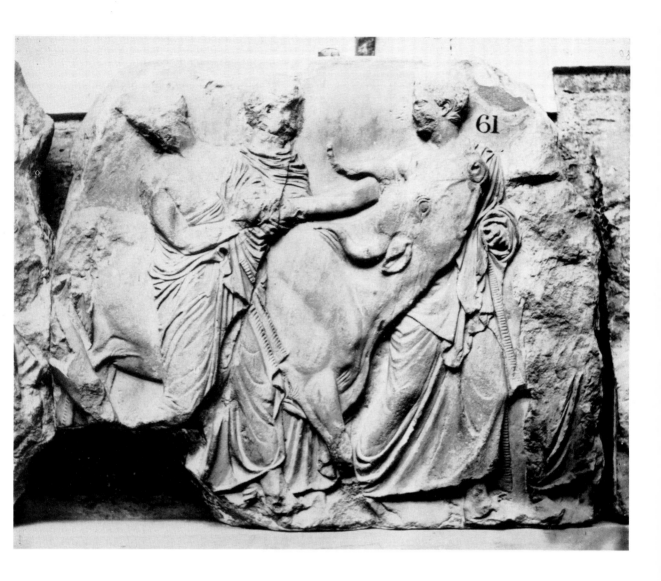

80. ANONYMOUS (Mansell Collection)

[On grey card] Left: *Athens Parthenon part of N. Frieze BM.*
Right: *north XXII m* [pencil number *651*, bottom left-hand
corner of print].

This is in the British Museum, set against the unplastered section of the brick wall. The painted reference numbers on the pieces of the slab 98 and 177 have now been removed. North frieze slab XXII, figures 64, 65 and 66: original marble, together with casts of the surviving fragments still in Athens (note the joins for the different sections as cast, especially in front of the horse) to make up the slab as far as possible, giving a fuller impression of the slab as it originally was than is now possible after the removal of the added casts.

Catalogue no. 9956.
27.50 x 22.20.

81. STILLMAN, 1869

[Signed on print with monogram and full name, and '69'. Labelled on print by Stillman:] *Bas Relief Temple of Victory.* [On blue-grey card] Left: *Athens Victory, figure of, from the Temple of Victory.* Right: *Figure of Victory, from the Temple of Victory.*

It is, of course, not from the temple itself, but from the 'Nike balustrade' which surrounded it. With the other sculpture and architectural fragments that surround it, it was photographed by Stillman when it was kept in the temple itself.

Plate 24 in *The Acropolis of Athens.*
Catalogue no. 9874.
18.50 x 24.00.

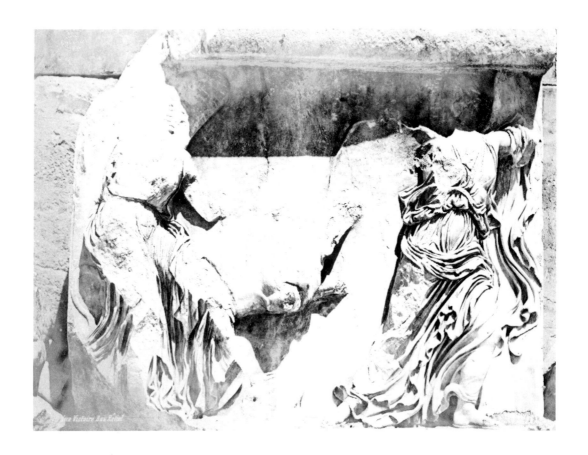

82. SEBAH

101 Une Victoire. [On grey card] Left: *Athens Parthenon Relief Victory.* Right: *mXXXIX*

This is not in fact slab **XXXIX** from the south frieze of the Parthenon, as Sir Lawrence thought, but part of the Nike balustrade. Note the overhanging band of stone at the top of the relief. The stonework in the background and the other pieces of stone to the left of the slab show that this was photographed on Sébah's visit to Athens in the early 1870s, while it was stored in the temple.

Sébah 101.
Catalogue no. 9968.
34.00 x 26.00.

83. SEBAH

Bas relief trouvé au Théâtre de Bacchus. Athens, Relief from the
Theatre of Dionysus.

This is now Athens National Museum
259, a neo-Classical relief (the surface
of the slab is curved) dated to the first
century BC and found in the 1862 exca-
vation of the Theatre of Dionysus.

It is interesting to compare the
drawing (fig. 7, p. 16) by A.S. Rouso-
poulos, from the publication of the exca-
vations in Ἀρχαιολοικὴ Ἐφημερις *(The*
Archaeological Annual) of 1862, with this
near-contemporary photograph; good
though the drawing is, the photograph
gives a far better impression of the
original. The relief probably belongs,
like the companion NM 260, to the
improvement of the stage after the
destruction of Athens by Sulla in 88 BC.
The ground on which the figure is carved
(like NM 260) has a curved outer surface.

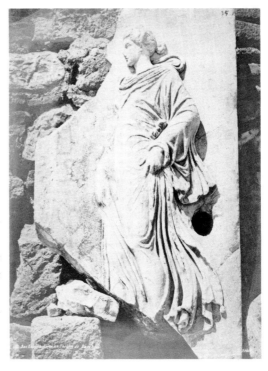

Sébah 102.
Catalogue no. 9868.
26.00 x 34.00.

84. SEBAH

Bas Relief au Musée d'Athènes

The stele of Polyxene, NM 723, found in the Kerameikos (*Dipylon*) cemetery, plus two other stelai to either side. Fragments broken at the top right of the stele, to the left of Polyxene's head and the next below, are not now visible in the original, which is here entirely plaster. There is now an additional recent break at the top of the right-hand moulding of the pediment, clearly visible in the German Archaeological Institute photograph in Clairmont but which in this picture is much smaller. Here Sébah shows the original moulding intact where there is now a break.

H. Diepolder, *Die attischen Grabreliefs des 5 and 4 Jahrhundents v Chr.*, 43 f., pl. 40 (the National Museum plate with stool leg still damaged) puts it in the 350s BC. Compare also C. Clairmont, *Gravestone and epigram*, Mainz, 1970, No. 50, p. 126, pl. 23. The modern photograph used here from the German Archaeological Institute is not as good as Sébah's, which shows detail more clearly. The left leg of the stool is unrestored here; it was later restored.

The stele partly visible to the left is probably NM 725, of Eupraxis giving her hand to her husband Miltiades. Found in Piraeus.

Sébah 114.

Catalogue no. 9832.

26.00 x 34.00.

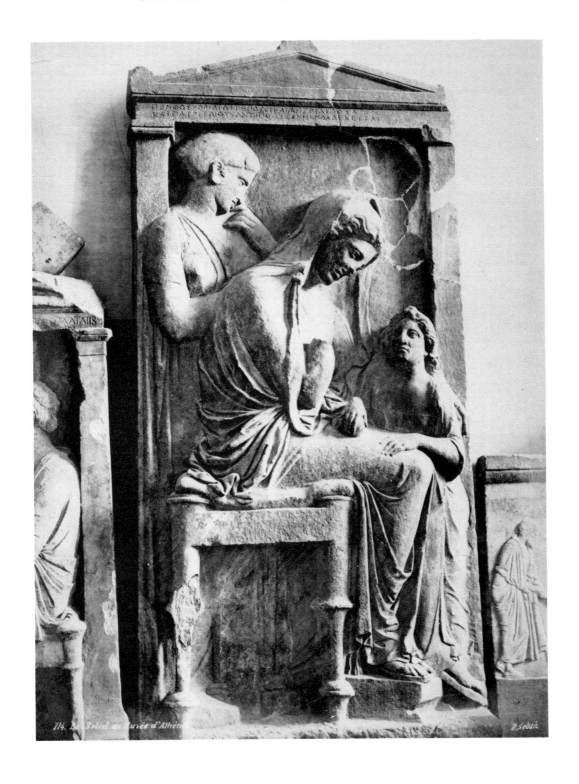

85. SEBAH

Bas-relief (Tombeau)

The stele of Demetra and Pamphile, from the Kerameikos, contained in a wooden surrounding, like the stele of Hegeso, still in Kerameikos. Damage to the surface of the negative is noticeable on the upper part of the frame of the stele.

A favourite with nineteenth-century photographers, this was also photographed by Stillman in 1882, and by another, anonymous, photographer (the photograph is in an album in the Department of Greek and Roman Antiquities at the British Museum). It was still in the Kerameikos in 1881.

Sébah 118.
Catalogue no. 9831.
26.00 x 34.00.

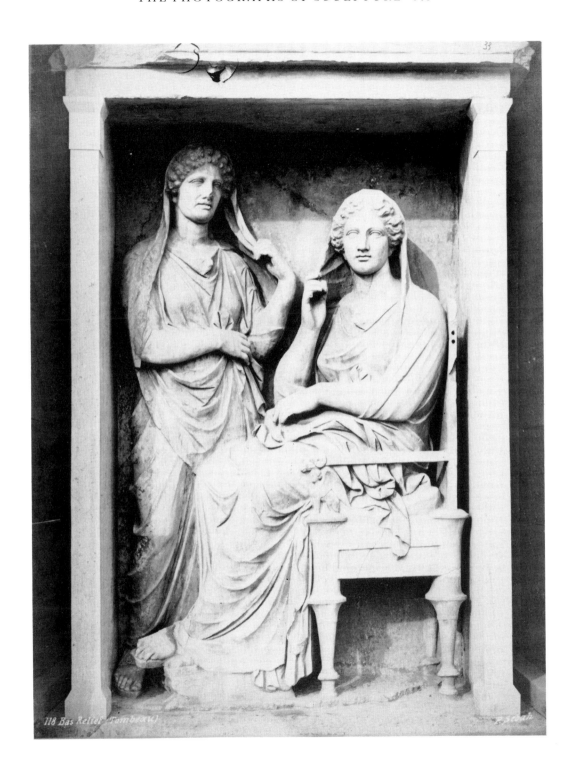

86. SEBAH

Bas-relief (tombeau)

The stele of Hegeso from the Kerameikos (now in the National Museum). Here it is supported on loose earth (the bottom of the stele is damaged) within a wooden frame, against wooden planks, and displayed in the Kerameikos itself. It was still in Kerameikos in 1881. The print is marked '*34*' in black.

Sébah 119.
Catalogue no. 9829.
26.00 x 34.00.

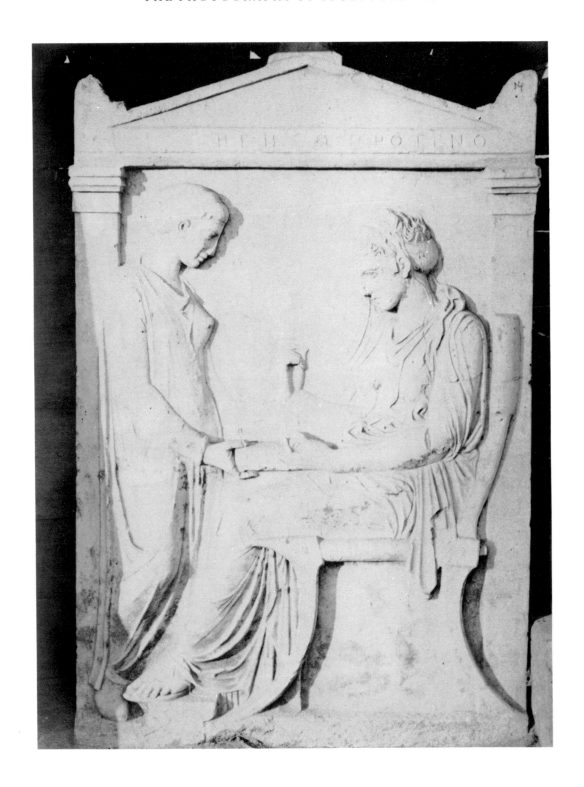

87. SEBAH

Bas-relief au Temple de Thesee Stele (fig. 11, p. 24.)

The Theseum, or temple of Hephaistos, like other Classical buildings was used as a store place for sculptures. (R. Kekulé, *Die Antiken Bildwerke in Theseion zu Athen*, Leipzig, 1869). This is the stele of Archestrate, now Athens National Museum 722. Found in Attica, at Markopoulo, in 1830, according to V. Stais, *Marbres et bronzes du Musée nationale.* Late fourth-century. See also Clairmont *op. cit.*, No. 52 Plate 84 L, dated to the second quarter of the fourth century, p. 129, and also Plate 23. It was also recorded in the National Museum in 1881 (Sybel 69).

The right-hand acroterion is now restored in plaster.

Catalogue no. 9833.
25.50 x 34.00.

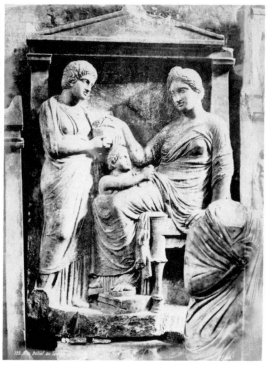

88. ANONYMOUS

Rives No. 74.
'102' in white on print. Print embossed (very faintly) on
left-hand side, with what looks like crossed swords.

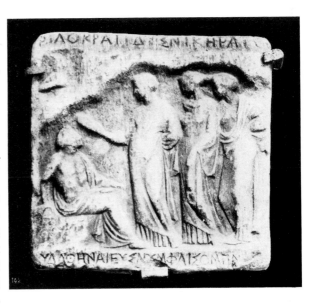

From the same series as Catalogue no. 9830 (Plate 89), and mounted on the same grey card (which differs from the white card of the Sébah photographs of stelai). Like Plate 89, this is very dark, almost black, rather than the brown colour of Sébah's prints.

Votive stele, dedicated by Philocrates, son of Nikeratos of the deme of Kydathenon to the Ompnian Nymphs.

It was found on the hill of the Nymphs by the Pnyx in Athens according to Pittakis, *L'Ancien Athènes* 60, but what his evidence for this was is not clear, since it was already in the Nani Museum in the eighteenth century, and was illustrated by Zanettus, *Dichiarazione di un basso relievo Greco del Museo Nani Venet.*, 1768.

As a work of art, it is obviously inferior to the previously illustrated examples of Athenian grave reliefs, and it is something of a puzzle why this was in Sir Lawrence's collection, though it is obviously a first-rate photograph.

R. Feubel, *Die Attischen Nymphen reliefs und ihre vorbilder*, Dissertation; Heidelburg, 1935.

Catalogue no. 9834.
20.50 x 16.76.

89. ANONYMOUS

'117' in white on print. *Stele (part of)*

See A. Conze, *Die Attischen Grabreliefs*, II.1, CLXX. In Avignon, Musée Calvet (No. 31), formerly Musée Nani.

This photograph is from the same series as the previous plate, which also was once in the Musée Nani. It is an anonymous grave stele.

Catalogue no. 9830.

18.00 x 24.00.

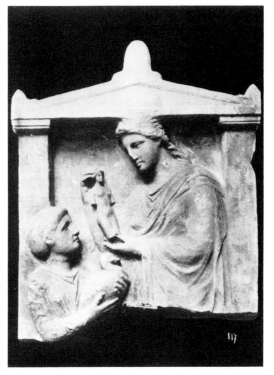

THE PHOTOGRAPHS OF BYZANTINE CHURCHES

Finally, the collection includes some view of Byzantine churches, and some other fragments. Sir Lawrence continued his interest in medieval topics, to judge from other photographs in his collection, even though these were no longer themes pursued in his paintings. The Byzantine churches included here were favourites of the nineteenth-century photographers who worked in Athens, and several versions survive. Sébah of course, working in Constantinople, included the Byzantine buildings of that city in his catalogue. By contrast, Stillman rigorously excluded such post-Classical structures.

90. SEBAH

Eglise Byzantine. Athens Church (Kapnikarea) View from south side.

Note the gas lamp attached to the building's side. This, of course, has now been removed, but the holes where it was fixed, and a groove hacked into the stonework of the church for the gas pipe, can still be seen. The church dates to the third quarter of the eleventh century. Sébah's view shows it in the middle of the small square created round it, with the opening of the new Hermes Street as part of the redevelopment of the city plan after the War of Independence.

Sébah 89.
Catalogue no. 8466.
34.00 x 26.00.

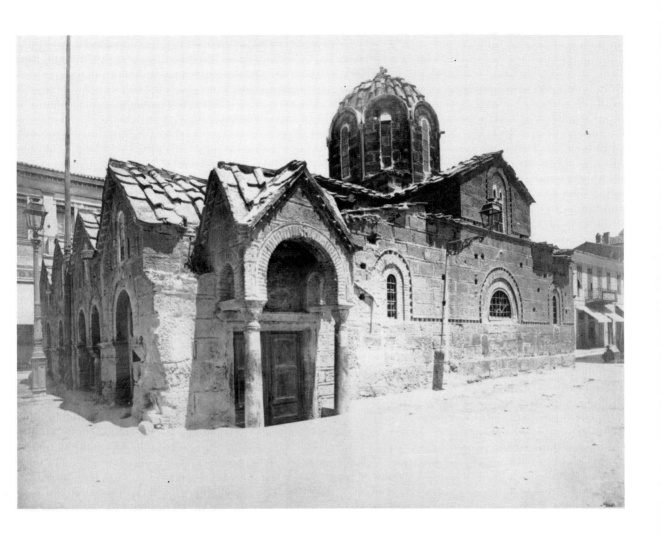

91. SEBAH

L'Ancien Cathedrale

Athens Old Cathedral [in ink, continued in pencil] *from N.W.* [Church of Panagia Gorgoepikoos or Agios Eleutherios] *5* [in ink on print].

The Panayia Gorgoepikoos, built towards the end of the twelfth century, was known as the 'little' or 'old' cathedral in contrast to the modern cathedral at its side which was started shortly after the end of the War of Independence. In fact it never was the church of the Bishop of Athens, which was rather Agios Panteleimon in the bazaar area.

Sébah 87.
Catalogue no. 8467.
34.00 x 26.00.

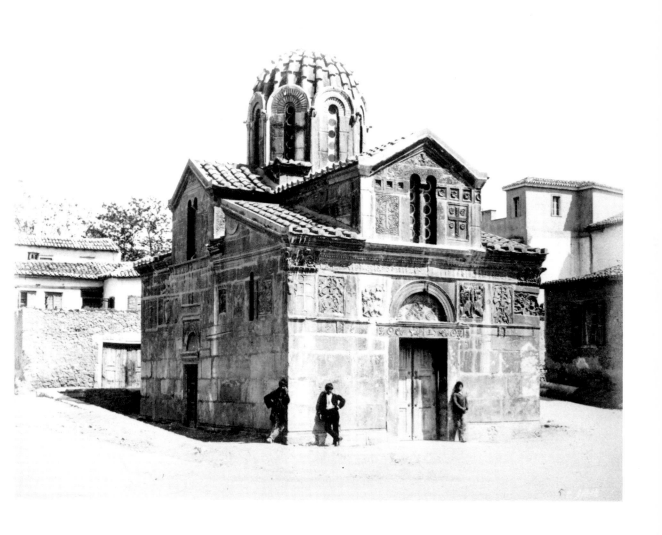

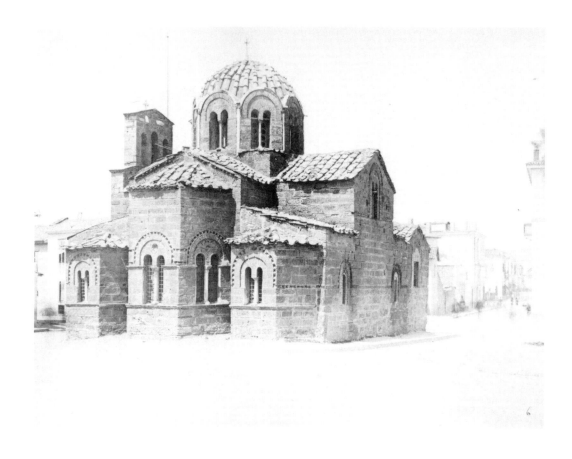

92. SEBAH

Eglise Byzantine St. Theodore. Athens Church of St. Theodore [in pencil] *from N.E. 6* [in ink on print].

The church of Ayii Theodori dating to the middle of the eleventh century AD, was re-built in the twelfth century. The name implies that the dedication was to more than one St Theodore.

Another favourite church with nineteenth-century photographers. This was situated at the corner of Klafthmonos Square, where a new square was created for it in the new city plan of the 1830s. Again, note the shadowy figure in the street to the right of someone who did not stand still for long enough to be fully recorded in the photograph.

Sébah 88.
Catalogue no. 8468.
34.00 x 26.00.

93. BONFILS 1870/1

Athens Fragments of sculpture

A mystery. A mortared rubble wall of a ruined building, and arranged in the courtyard in front of it, in quasi-architectural order, a mass of Byzantine fragments which once decorated churches. Presumably these were gathered by K. Pittakis from the numerous churches of the Plaka ruined in the War of Independence, and stored in the ruins of the Great Panagia. See Angelike Kokkou, *Concern for the Antiquities of Greece, and the first Museums* (Η μέριμνα γιά τίς αρχαιότητες στήν Ελλάδα καί τά πρῶτα Μουσεῖα, Athens, 1977) p. 170, fig. 70 (I am grateful to Theodore Koukoulis for putting me on to this reference).

Bonfils 289.
Catalogue no. 9786.
27.60 x 21.30.

BIBLIOGRAPHY

SIR LAWRENCE ALMA TADEMA

Swanson, Vern G., *Sir Lawrence Alma Tadema*. The Painter of the Victorian vision of the Ancient World, London, 1977.

PHOTOGRAPHY – GENERAL

Bartram, Michael, *The Pre-Raphaelite Camera*. Aspects of Victorian Photography, London, 1985.

Gernsheim, Helmut and Alison, *The History of Photography*, London, 1955 (2nd edition 1969).

NINETEENTH-CENTURY PHOTOGRAPHS OF GREECE

Benaki Museum, Athens, 1839–1900 *A Photographic Record* (Exhibition Catalogue), Athens, 1985 (In English).

Szegedy-Maszak, Andrew, *True Illusions: Early Photographs of Athens*, J. Paul Getty Museum Journal, 15 (1987), pp. 125–138.

BONFILS

Rockett, Will. H., *The Bonfils Story*, Aramco World Magazine, Nov.–Dec. 1983.

Thomas, Ritchie, 'Bonfils and Son Egypt, Greece and the Levant; 1867–1894' *History of Photography*, Vol. 3, 1979, pp. 33–46.

SEBAH

Çizgen, Engin, *Photography in the Ottoman Empire*, Istanbul, 1987 (In English).

STILLMAN

Arnakis, G.G., *Consul Stillman and the Cretan Revolution of 1866*, Athens, 1969 (Proceedings of 2nd Cretological Congress).

Ehrenkranz, Anne, (ed.)., *Poetic Localities*, New York, 1988.

Lindquist Cock, Elizabeth, 'Stillman, Ruskin and Rossetti: The Struggle Between Nature and Art' *History of Photography*, Vol. 3, 1979, pp. 1–13.

Stillman, W.J., *Autobiography of a Journalist*, London, 1901.

INDEX

Bold figures indicate plate numbers